EARLSTON H S	
2 4 NOV 1999	
1.4 SE	-P- 2012
2 OCT 2001 - 5 APR 2002	
18' NOV 2002	
- 2 DEC 2009	
1 7 DEC 2009	
32469	6
NUMBER	4696
CLASS 7759.4	
SCOTTISH BORDERS LIBRARY SERVICE ST MARY'S MILL SELKIRK TD7 5EW	
Tel: Selkirk (01750) 20842	
This book is due for return on stamped above. Please return it to the Branch f	
	100% recycled paper

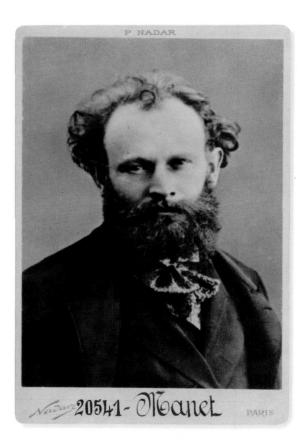

plan las 1000 707 BROADWAY. Manet's "calling card"

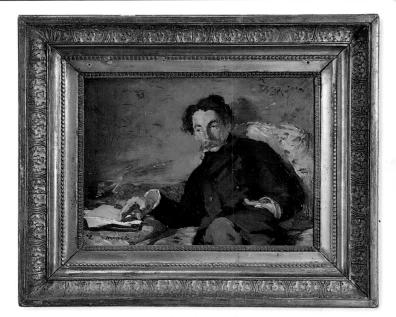

Portrait of Stéphane Mallarmé, 1876

Emile Zola's booklet defending Manet's art

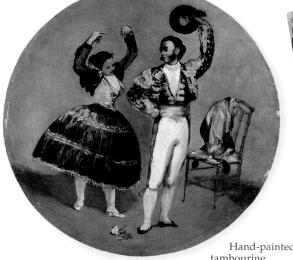

Hand-painted tambourine

Poster for the Ambassadeurs theatre

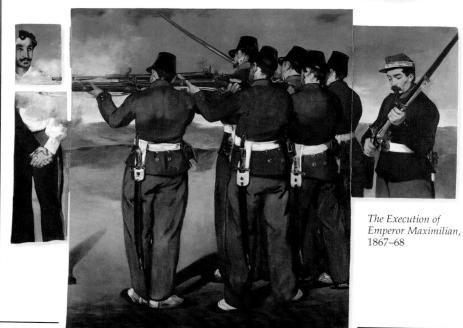

The Barricade

EYEWITNESS O GUIDES

PATRICIA WRIGHT

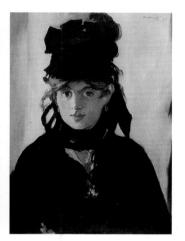

Berthe Morisot with a Bunch of Violets, 1872

amieres, 31 Juilles 1883

Madame,

Breach, mai, jo bound in prin, di je brievet angemet han "canner ander denhans en mared allahammet de cat acchant at de regarde. Sam hans Romant

Sover Sarry Sance annue derile ges på på for op ne gened og parke de har till and og som annar som par et algengrins, den delphande och ander me parket benange derile i og delate benande og soll seitante des tablande den delaratede omgenkligteten Jetart hente jone alses aktiviskaden og parket parket fande og

point je varies de Manuel qui avait sente un point pointe de des labours e de James un biet qui l'ans conset que dontes de la la pointe se la tenerente estemant de la consectante de la consectante tenerente point pois poise de la consectante desponde

C. transport to set transform plast till griefe nor prostant ; to "remain fort que je til the theman it. pro provet to "Surger domas que on this atter cannor constraint dens on the tota , gjord and , go'd and the second to the second method in a second second to set, is quelle register metodie to som a solo apole

Costad , j' Mais bie decider - no jamais 100

Letter from Victorine Meurent to Madame Manet

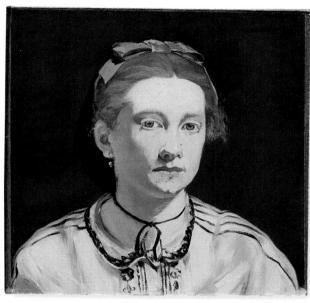

Portrait of Victorine Meurent, 1862

main to matheway a find rappeland alle main to matheway of finder the main for a hadar of a completeness

a serie de la constance de la

an delamine e tans informes dela denor na dela mine e tans informes de la como parte de la como de la como de la como de ante en de la como de la como de la como tana en el como de la como de la como tana en el como de la como de la como tana en el como parte de la como de la como any la la como parte de la como de la como la como de la como parte de la como de la como la como de la como parte de la como de la como la como de la como parte de la como dela como la como de la como parte de la como de la como la como de la como parte de la como dela como la como de la

Finisting agine , Madames, this do most shadowing the plant more of the plant signed

Patonie Manuels bullant a la suire. Atrices.

Violets

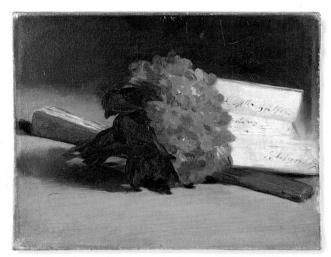

DORLING KINDERSLEY LONDON • NEW YORK • MOSCOW • SYDNEY IN ASSOCIATION WITH THE NATIONAL GALLERY, LONDON

Contents

The headstrong youth Copying the masters Manet as student 12 The first rejection 14 Bohemian Paris "The Heroism of Modern Life" 18Spanish vogue 20 Victorine Meurent Salon of the rejected 24 A bourgeois scandal Suzanne Leenhoff 28 A new controversy 30 An elegant realism The still life The cycle of life 36 Spain and Japan Beggar-philosopher A misjudged masterpiece

42 The Maximilian affair The fall of Paris 46 Manet and Morisot Detachment and intimacy 50 The respectable rebel 52 Manet or Monet? An Impressionist landscape 56 Reign of the courtesan 58 The final masterpiece 60 Manet's death 62 Key dates; Manet collections Glossary; Works on show Index; Acknowledgments

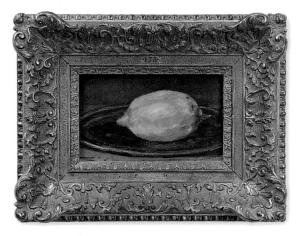

The Lemon, 1881

The headstrong youth

EDOUARD MANET WAS NO child prodigy. He was born on 23 January 1832 into the comfortable world of his wealthy bourgeois parents, Auguste and Eugenie-Desirée Manet, and his childhood years passed uneventfully.

When Edouard announced his ambition to be an artist, his father was reluctant, suggesting instead a naval career. At the age of 16, Edouard embarked on a six-month voyage to Rio de Janeiro, but contrary to his father's hopes, the

voyage served only to strengthen his resolve. On his return, Manet's career as a painter began. In 1850 he registered as a copyist in the Louvre (pp. 8–9), and as a student at Thomas Couture's studio (pp. 10–11).

ANCIENNEMENT 5 RUE DES PETITS AUGUSTINS NAQUIT

EDOUARD MANET

1832 - 1883

MANET'S BIRTHPLACE 9 rue des Petits-Augustine

(now rue Bonaparte), opposite the Louvre, Paris.

PORTRAIT OF M. MANET PERE Auguste Manet was a high-ranking civil servant who became a judge of the Court of First Instance at the Seine. This is the earliest of Manet's portraits of his father, an etching that he made in 1860.

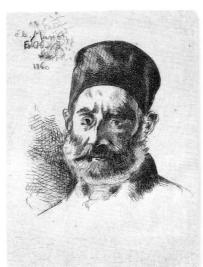

MANET AS A BOY

Manet seems to have been a happy, well-balanced child, with an affectionate relationship with his family, and a pronounced dislike for scholarly activities. At school (where he had to stay on for an extra year) he revealed no particular aptitude or inclination to study. His talent for drawing, however, had manifested itself early on, and it soon became clear that Edouard would not follow in his father's footsteps and enter the legal profession.

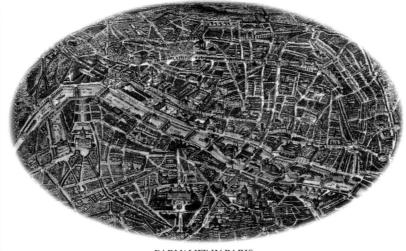

EARLY LIFE IN PARIS Manet started school at the age of six at Abbé Poiloup's at Vaurigard. His education continued at the Collège Rollin, a boarding school for sons of the wealthy, which he entered at the age of 12, and it was there that he first became friends with Antonin Proust (p. 49). Soon after, his family moved to rue Mont-Thabor, near the Tuileries Gardens.

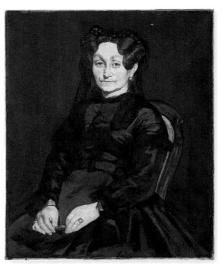

MANET MERE 1863; 105 x 80 cm (41¼ x 31½ in) In this rather austere portrait of his mother

PORTRAIT OF MME.

portrait of his mother in deep mourning, painted shortly after his father's death in 1862 (pp. 26-27), Manet pays tribute to her strength of character. She was a moral as well as financial support to Manet throughout his life. His earliest letters reveal a warmth towards his parents that is not always apparent in his paintings of them (p. 48).

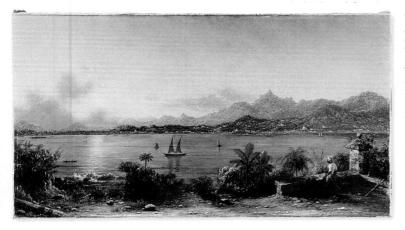

THE STEAMER

1864; 14.3 x 18.5 cm (5% x 7% in); graphite and watercolour On the whole, Manet found the sailor's life very dull: "Nothing but sea and sky, always the same things, it's stupid." During the long empty hours he produced drawings and watercolours of ships, committing to memory his observations for later works such as this watercolour (right) which he made in a sketchbook nearly twenty years later.

PIERROT IVRE

c.1849; watercolour and pen; specification not available Manet gained a reputation for his talent for caricature and drew several of his shipmates (left). His first "commission" to retouch the damaged coloured rind on the cargo of cheeses, caused an outbreak of lead poisoning in Brazil.

ANOTHER WORLD

Rio de Janeiro (below), as it appeared to Manet in 1848. In a letter to his mother, he recounted seeing a slave market, which he described as, "a rather revolting spectacle for people like us".

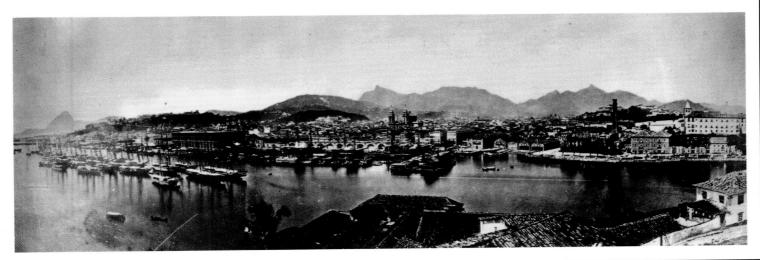

THE HARBOUR AT RIO

Martin Johnson Head; 1864; 46.7 × 84.7 cm (18½ × 33½ in) This painting of Rio de Janeiro conveys the exotic landscape that awaited Manet. In his letters home, he described the carnival at Rio, in particular the Brazilian ladies "... on their balconies, bombarding every gentleman who passes with multicoloured wax balls filled with water". It was an enduring image which would recur much later (pp. 46–47).

SHIP'S COMPASS Edouard failed his naval entrance exam twice, but could have joined after completing a trial voyage.

Copying the masters

ART SUPPLIERS Le rapin ("the rat") was a common nickname for the painter's apprentice or young student. It was common practice for artist's palettes to be used as shop signs. Here we can see the "rat" dressed in a suit and soft hat, presumably off to work with a portfolio and easel. ${
m M}_{
m AKING}$ direct and thorough copies in front of the Old Masters was regarded as an essential part of a young painter's training. A typical day for an art student in the 1850s would begin with the morning spent drawing from plaster cast or life models; the afternoon would be spent copying from master works hanging in the Louvre. As a student, Manet also made trips abroad in order to study and make copies from paintings – in 1852 and 1853, he visited Holland and Italy, returning there in 1857, when he copied Titian's Venus of Urbino. From the very beginning Manet drew inspiration from the Old Masters, and he made no secret of his debts to them. They provided him with models for some of his greatest paintings – models for which he created completely new, sometimes openly

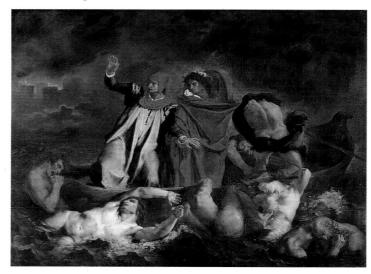

irreverent, and thoroughly modern settings (pp. 24–25, 28–29 & 38–39).

THE BARQUE OF DANTE Eugène Delacroix; 1822; $189 \times 246 \text{ cm} (74\% \times 96\% \text{ in})$ Delacroix was the undisputed leader of the Romantic school and arguably the greatest French painter of the first half of the 19th century. From an aristocratic background he entered into the studio of a distinguished Neo-Classicist, but soon met, and was profoundly influenced by, the remarkable Théodore Géricault. His famous painting *The Raft of the Medusa* (1819) hung in the Louvre, and was the inspiration for this painting.

DELACROIX'S STUDIO This engraving by Best shows the studio Delacroix took in the Place de Furstemberg following his commission to decorate a chapel in a nearby church.

VENUS OF URBINO (AFTER TITIAN) 1857; 119 x 165 cm (46³/₄ x 65 in) This small copy (right) of Titian's Venus of Urbino (1538) is one of a group of copies Manet made at the very beginning of his career. The majority of Manet's earliest paintings are, in fact, copies of works by the Old Masters, and he made this one whilst on a trip to Italy in the autumn of 1857. This naked Venus was the most enduring image he brought home with him, as we can see from her metamorphosis into a very different kind of Venus, Olympia, six years later (pp. 28-29).

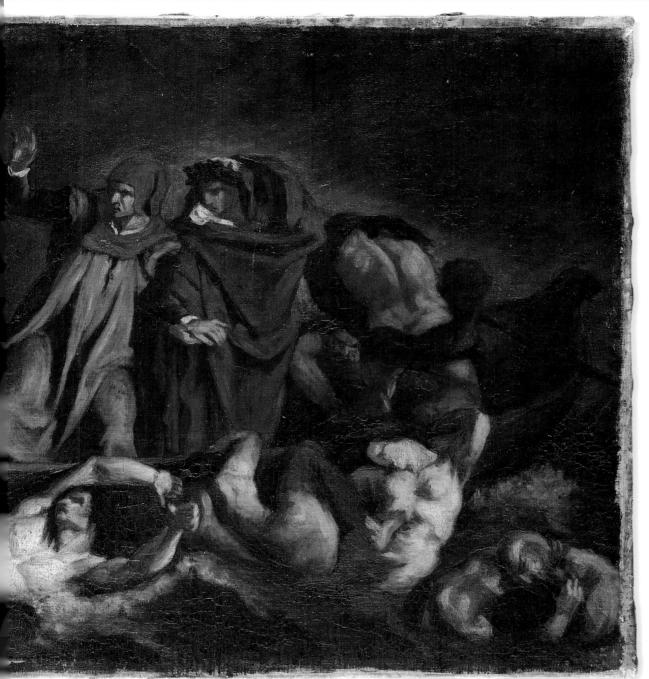

CAREFUL COPY Manet made at least two copies of Delacroix's *Barque of Dante*. This is thought to be the first version, and executed with careful attention to detail. Another version, done around the same time, is more of a loose sketch.

SUBDUED COLOUR Although a faithful copy, Manet's painting is more subdued than the original; it is a closer-toned work, dominated by a range of browns. All that remains of Delacroix's passages of striking colour is the rich red cowl worn by the figure of Virgil.

COUTURE'S INFLUENCE When Manet made this copy, he was Couture's student (pp. 10–11). The visible concern for overall harmony of colour and tone here exhibited by Manet may well have been a direct result of his teacher's instruction.

DORMANT COLOUR Many years later, the unusual colour range of Delacroix's Barque of Dante appears again, revitalized in Manet's "beggar-philosopher" series (pp. 38-39). The strong colours of red, brown, and blue reappear in the form of the beggar's hat, cloak, and tunic, this time with an intensity of hue to match the original.

The Barque of Dante (after Delacroix)

c.1858; 33 x 41 cm (13 x 16¼ in)

Delacroix was a highly respected artist, but had a reputation for being cold and unapproachable. To make copies of his magnificent *Barque of Dante*, Manet and fellow student Antonin Proust visited him to ask his permission in person. They were received with great courtesy, if not great warmth, and Proust later recalled Manet saying, "It's not Delacroix who is cold; his theories are glacial". When Manet's art was being criticized, Delacroix, too old and ill to help influence the Salon jury, is reputed to have said, "I wish I had been able to defend that man".

COPYISTS IN THE LOUVRE By the end of five years as a student, it was expected that the young artist would have developed a firm grasp of the Old Masters' techniques. These would then be applied to their own paintings, thereby perpetuating the same stylistic devices. In this engraving, the young woman (far left) is engaged in a copy of Tintoretto's Self-Portrait, which Manet also copied in 1855.

"THE RAT" This cartoon depicts a "rapin" (p. 8), here used as a derogatory name for an older student who lacked ability.

Manet as student

IN JANUARY 1850 MANET, together with his old school friend Antonin Proust, became one of approximately 30 students under Thomas Couture's tutelage. Couture had set himself apart from the established *Ecoles* ("Art Academies"), taking no part in their system of competitions,

medals, and prizes. Though he did place great emphasis on classical composition, Couture valued spontaneity and freshness, and steered his students away from the academic obsession with detail. Even so, there were frequent disagreements between Manet and his tutor, and their personalities

clashed on many occasions. Manet rejected much of Couture's formal teaching, and Couture, in return, attempted to undermine his rebellious student. But Couture did influence Manet's art, and Manet must have known this at the time as he remained Couture's student for six years.

Romans of the Decadence

Thomas Couture; 1847; 466 x 775 cm (183½ x 3,05 in) This was the painting that established Thomas Couture as an independent successful artist. He exhibited it at the 1847 Salon and set up his *atelier* (studio) shortly afterwards. The significance of this painting in relation to Manet lies in the number of pictorial sources he used; he borrows from Titian. Rubens, and Marcantonio Raimondi (p. 24). In the manifesto outlining his artistic beliefs, Couture stressed the importance of "Study[ing] all the schools to reproduce the wonders of nature and the ideals of our time in a noble and elevated style".

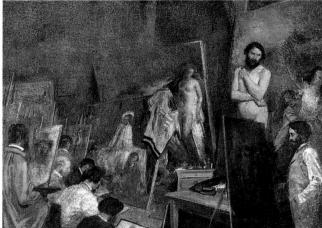

THE STUDIO OF THOMAS COUTURE Anonymous; 1854–55; 46 x 61 cm (18 x 24 in) Thomas Couture held a romantic view of the artist as an isolated genius, and it was largely because of this, and his independent stance, that he was popular with young artists.

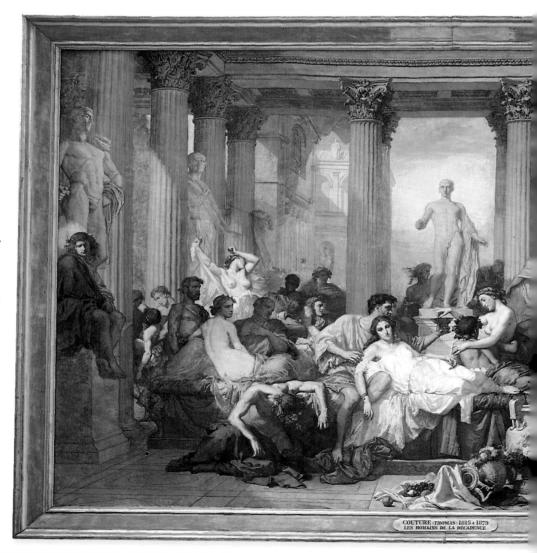

EARLY REPUBLICAN LEANINGS The years Manet spent as a student in Paris were politically turbulent ones. Following Louis Napoleon's *coup d'état* in December 1851, Federal troops were sent in to quash the Republican-led opposition – resulting in the "Massacre of the Boulevards". Manet and Proust ventured out into the midst of the rioting. They were arrested and spent the night in a police station. HEAD OF A BOY c.1850; 37 x 30 cm (14% x 11% in); pastel on paper This delicate drawing was done in Manet's first year at Couture's studio. It is noticeably more restrained than later works, and displays a concern for careful and systematic buildup of form.

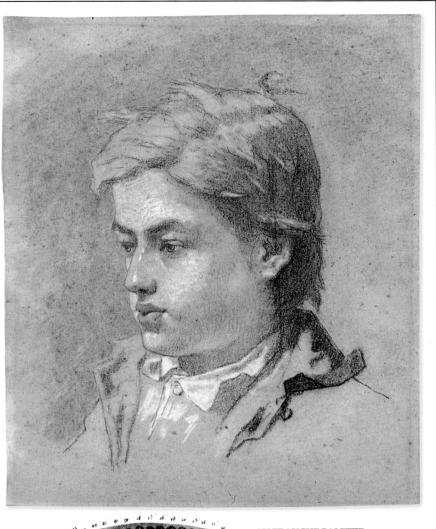

AN EBAUCHE PALETTE In every student's training, great emphasis was given to the *ébauche* – or underpainting of a painting. Students were faught to render, quickly and freely, composition, light and shade, and simplified colour before moving on to the tightly controlled finishing stages. Unlike his contemporaries, Couture was known to allow ébauche elements to show in his finished painting.

ENROLMENT FEE RECEIPT Couture had become disillusioned early on by the Academic system of trials and competitions, and looked elsewhere for patronage. His great success at the Salon of 1847 enabled him to open his own atelier the same year. His classes contained between 25 and 35 students, who were each charged a yearly fee of 120 francs. This note is Couture's handwritten receipt for a fee paid by Manet in 1856.

Je manut la Source D. Go & Hour Ja Cotisation "In 12 ferrier 1856 Taris 10 forins 1855

37507

LITERARY FRIEND Manet met the poet Charles Baudelaire in 1858. Though Baudelaire was 11 years Manet's senior, they became good friends, and enjoyed a mutually inspirational relationship. Baudelaire had entered the public eye when his "Les Fleurs du Mal" was banned in 1857 and he faced charges of offending public morality. Like Manet, he was a *flâneur* (pp. 14–15), and a leading member of the Paris avant-garde.

The first rejection

AFTER LEAVING COUTURE'S establishment in 1856, Manet set up studio in rue Lavoisier. It was here that he painted *The Absinthe Drinker*, his first submission to the Salon of 1859, and his first rejection. This disappointment marked the beginning of Manet's life-long quest for recognition through and from the Paris Salons. Throughout his career he met with

slander and ridicule, and although he eventually did receive official recognition, it arrived almost too late (p. 58). Couture was critical of Manet's *Absinthe Drinker* and, as a member of the jury, probably instrumental in its rejection from that year's Salon. At that time the Salon exhibition was virtually the only real showcase for artists to

exhibit their work; the few private galleries in Paris rarely mounted exhibitions and no other artists' forum really existed.

ABSINTHE LABELS Absinthe was a powerful and highly addictive hallucinogenic liqueur. It acted on the nervecentres, rapidly inducing intoxication and delirium, and was thought to cause madness.

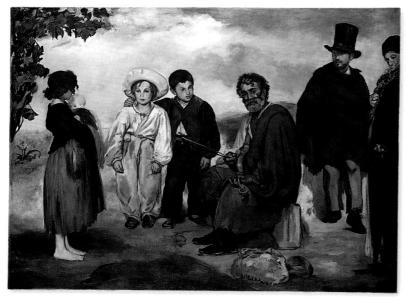

THE OLD MUSICIAN

1862; 187 x 248 cm (73% x 97% in) Manet's absinthe drinker appears once again in this later painting, as one of a group of "displaced" characters: the wandering Jew, the gypsy, and children from the slums – all inhabitants of the no-man's-land around Paris. This painting depicts Baudelaire's "floating subterranean lives in the great city" and corresponds to his concept of "the Heroism of Modern Life" (p. 16).

ABSINTHE

Edgar Degas; 1876; 92 x 68 cm (364x 264in)
Degas painted Absinthe 17 years
after Manet's Absinthe Drinker. In its
oblique perspective and the zigzag
pattern of the table tops, Absinthe
reveals a Japanese influence (pp. 36–37). It coincided with the release
of Emile Zola's "L'Assomoir" ("The
Drinking Club") – a novel tracing
a woman's downfall through
alcoholism and poverty (pp. 56–57).

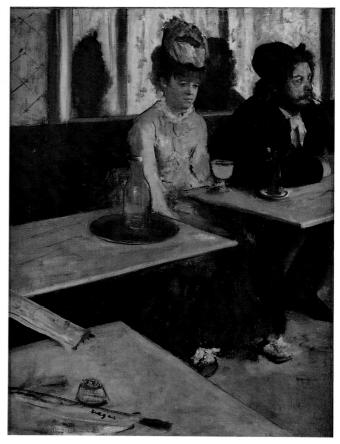

The Absinthe Drinker

1859-67; 181 x 106 cm (71¹/₄ x 41³/₄ in) The Absinthe Drinker was rejected from the Salon for a number of reasons. The "Baudelairian" subject matter of a drunken downand-out offended public morals, and the painting's loose handling and lack of definition - unprecedented in a work of this large scale - outraged the critics. Couture was also harshly critical of The Absinthe Drinker when Manet invited him to view it in his studio.

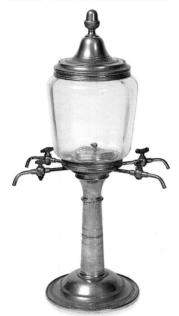

ABSINTHE FOUNTAIN Absinthe was served from fountains behind the bar. The liqueur was "sieved" through a spoonful of sugar into a glass. By 1874, two million gallons of absinthe a year were being consumed in France.

COUTURE'S LEGACY The close-toned overall harmony of browns and ochres in Manet's *Absinthe Drinker* reveal Couture's remaining influence. Manet was not yet using the rich colours and strong contrasts that characterize his later paintings.

EXTENDED CANVAS In 1859, the bottom part of this picture did not exist. Around 1867, Manet added a 40-cm (15%-in) strip of canvas, completing the figure and adding the bottle and glass of absinthe. It then became part of his "beggar-philosopher" series (pp. 38–39).

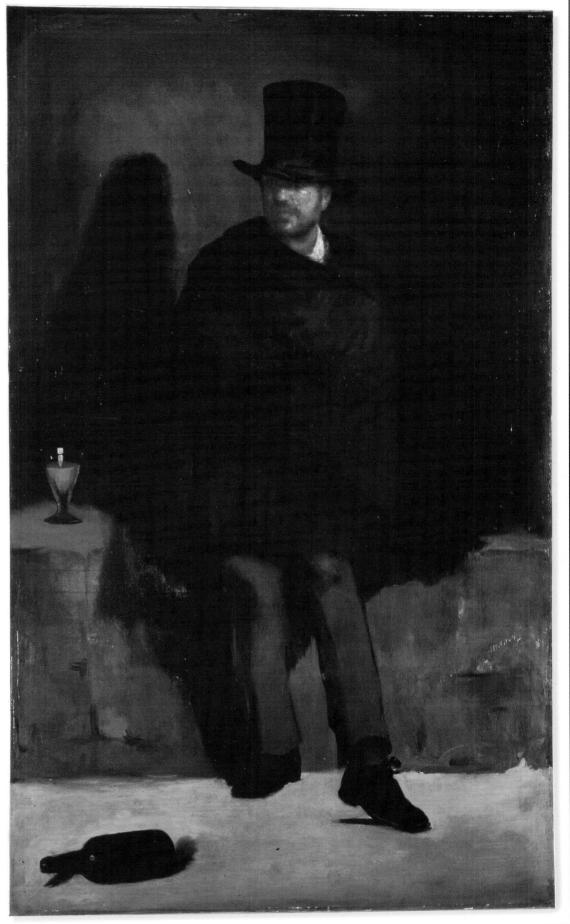

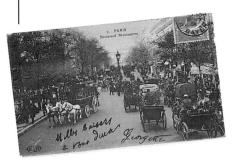

BOULEVARD MONTMARTRE In this photograph of a bustling new Boulevard Montmartre, we can see the long, straight thoroughfares of Baron Haussmann's (below) remodelled Paris.

Bohemian Paris

BY 1860 THE STREETS OF Paris were undergoing great transformation. Manet was very much the *flâneur* ("stroller" – p. 15, bottom left), and he daily frequented the most fashionable cafés to become a true connoisseur of life in the city. Paris and its

inhabitants provided Manet with subjects for paintings throughout his career; and the complexities of modern urban life combined together to become Manet's "motif". He drew inspiration from all levels of society, lending as much significance to *The Absinthe Drinker* (pp. 12–13) as to the wealthy and fashionable figures depicted in his *Music in the Tuileries* (pp. 16–17). With his refined manners, elegant dress, and more importantly, his concern with modernity and the commonplace, Manet embodied all the traits of a *flâneur*.

> Proposed boulevard, cutting through Parisian streets

HAUSSMANN PLAN This street plan reveals the brutal means adopted by Baron Haussmann to create wide boulevards by demolishing existing streets and housing.

CAFE TORTINI

Cafés constantly attracted Manet, who, as Duret said, "was driven by the need to tread the select ground of the true Parisian".

PHOTOGRAPH OF MANET "Fair-haired, twinkling, this Manet,From whom grace shone every way – Bearded Apollonian, Subtle, gay, and charming so,Had an air from top to toe Of the perfect gentleman." *Théodore de Banville*

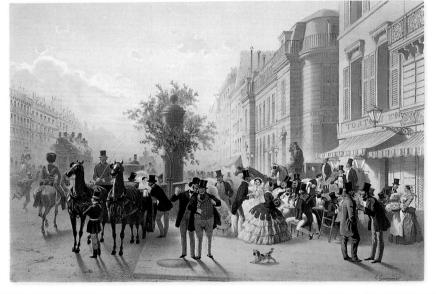

THE FASHIONABLE BEARD Manet was famous in his circle for his fashion conscious appearance. Some critics took this, unfairly, to be a mark of his lack of "seriousness".

HOMAGE TO DELACROIX

Henri Fantin-Latour; 1864; 160 x 250 cm (63 x 98½ in) Fantin-Latour's gathering of the artistic and literary avant-garde represents a show of unity, a new force to be reckoned with. It depicts Manet as an important figure, standing between the portrait of Delacroix (p. 8) and Baudelaire (p. 16). Fantin-Latour asserts himself as the creator of the painting with his self-portrait holding a palette.

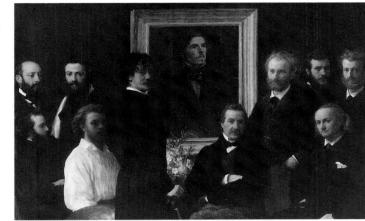

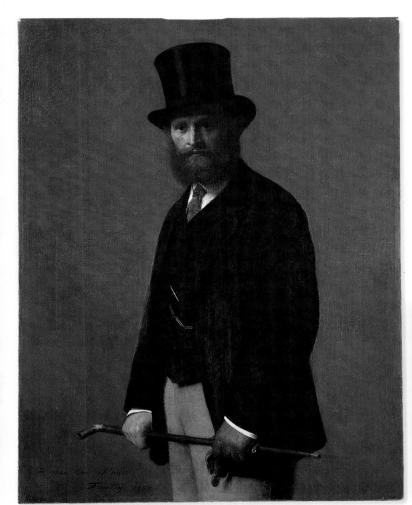

Contemporary

Contemporary silk top hat

FASHIONABLE PROP

Manet said of the top hat that it was one of the most difficult objects to draw. He obviously had a fondness for its peculiar shape, however, as he featured it often, notably in *Music in the Tuileries* (pp. 16–17). He apparently disliked the Bohemian look, and was always impeccably, usually formally dressed.

MANET'S IMAGE

19th-century dress gloves Contrary to the image we

have of Manet today – as the refined, well-dressed, gentleman painter – for years his own public imagined him to be a half-crazed, bohemian artist.

PORTRAIT OF EDOUARD MANET Henri Fantin-Latour; 1867; 117.5 x 90 cm (46¼ x 35½ in) Fantin-Latour's portrait is a true record of Manet's public image: an elegant flâneur. The flâneur was a particularly Parisian phenomenon who emerged in the 1830s. He was the sophisticated gentleman idler, well-practiced in the art of cool, detached observance of his city and its inhabitants. He had the dandy's meticulous attention to dress and manners, the difference being that he now also had intellectual, literary, and artistic concerns.

BOY WITH CHERRIES

1859; 67 x 54 cm (264 x 214 in) Manet's young studio assistant, Alexandre, was the model for this painting, begun in the studio at rue Lavoisier. Progress was disrupted however, when Manet discovered the dead body of his young model, who had hanged himself in the studio. The incident so affected Manet that he moved to a new studio in rue de la Victoire, where he completed *Boy with Cherries*, one of his earliest exhibited works. In 1864 Baudelaire wrote the prose poem "*La Corde*", based on Alexandre's suicide, and dedicated it to Manet.

"The Heroism of Modern Life"

 $M_{\rm ANET'S}$ *Music in the Tuileries* is one of the first truly "modern" paintings of the 19th century. Through its subject matter and innovative technique, it became a key work, influential in the development of many of the younger painters. Manet and Baudelaire were constant companions at this time, and Manet was instinctively drawn to Baudelaire's concept of "the Heroism of Modern life". Music in the Tuileries is a metaphor for that concept,

whereby "The spectacle of elegant life and the thousands of ephemeral existences floating through the labyrinths of a big city ... show that we have but to open our eyes to see our heroism".

Cobalt blue

Vermilion

MATERIALS

The violent reaction to Music in the Tuileries stemmed largely from Manet's isolated patches of colour, and "inconsistent" handling of the paint (where Manet, imitating reality, gave some areas sharp definition, and others almost none). Manet was using colours newly available to artists: cobalt blue, visible in the women's bonnets: and Naples yellow, used extensively throughout the painting.

Ivory black

Naples yellow Chrome orange

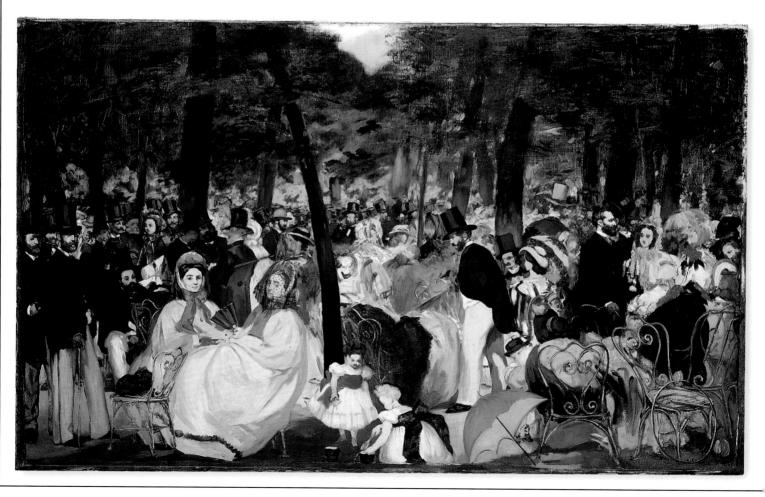

1862: 76 x 118 cm (30 x 46½ in)

Antonin Proust recalled how "the strollers in the park looked with interest at this elegantly clad painter who arranged his canvas, armed himself with his palette, and painted with as much serenity as he would have done in ĥis studio". Though Manet made studies en plein air, he did this painting in his studio. He did not exhibit it until 1863 where, at Martinet's studio, it provoked an angry response. Manet later recalled to Zola how "an exasperated visitor went so far as to threaten violence if Music in the *Tuileries* was allowed to remain in the exhibition hall".

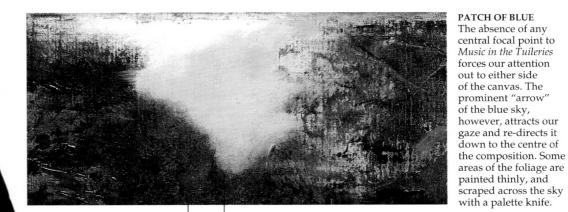

THE ARTIST'S WORLD

This is one of Manet's rare self-portraits, as a member of this fashionable Parisian crowd – ostensibly gathered to hear a military band. Manet stands with the equally elegant and aloof Count Albert de Balleroy (with whom he shared his first studio), surrounded by family and friends.

The legs act as verticals in addition to the tree trunks

Some areas of the foliage are applied in glazes over a warm earth base colour

The signature is painted as though it exists, physically, as part of the scene

Despite Manet's complete rejection of the artistic "laws" of the day, he makes recourse in this painting to traditional illusionism, employing an old trick of the trade with his signature: a visual joke, painted *trompe l'oeil* (p. 63) behind the child's hoop.

SYMMETRY AS A DEVICE below

The symmetrical "mirror image" of the two women helps prevent a central reading of the composition. Back to back, like duellists, they point with fan and umbrella to opposite sides of the painting. The figure of the woman with the umbrella who occupies the central position has almost no definition; we cannot "focus" on her, and so our attention is further diverted from the centre out to the edges of the composition, where the action takes place.

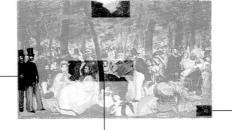

The man's face

rendered in a few

and beard are

crude strokes

The woman's profile under a veil is barely discernable

EUGENIE DE MONTIJO The Spanish Empress of France, she was a renowned beauty, and influenced Paris fashions.

Spanish vogue

 $M_{\rm ANET}$ was preoccupied with Spanish themes during the 1860s. This was crucial to his development and brought him his first success at the Salon, where he received honourable mention for The Spanish Singer. His early "Spanish" paintings (he produced 15 in two years) were influenced largely by the

Spanish vogue that had existed in Paris since the 1840s: the Louvre had already begun to acquire works by Spanish masters. But it wasn't until Manet actually visited Madrid in 1865 that the influence became profound, and he moved from the theatricality of the Spanish subject to an innovative use of paint and pictorial space, inspired mainly by Velázquez (p. 36).

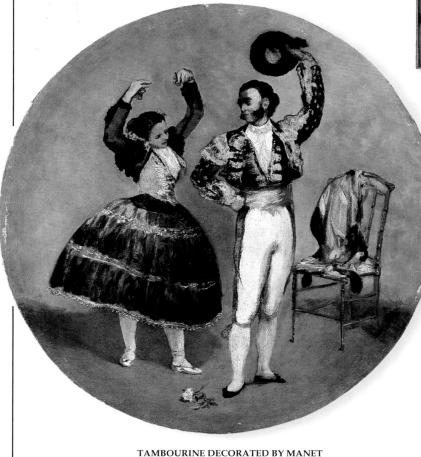

Manet always retained his admiration and enthusiasm for the colour and drama of Spain. He produced a series of painted tambourines for a benefit sale at the Hippodrome in 1879, in aid of the victims of a flood in the Spanish city of Murcia.

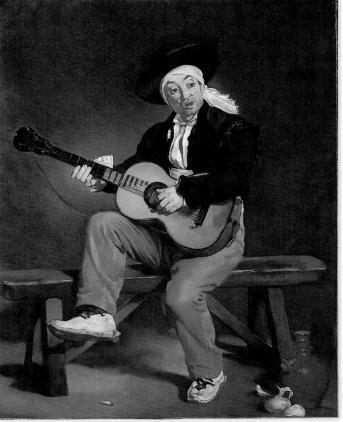

THE SPANISH SINGER

1860; 147 x 114 cm (58 x 45 in) Following the failure of The Absinthe Drinker (pp. 12-13), Proust recalled Manet saying, "Perhaps they will understand better if I do a Spanish character". This was indeed more acceptable than the "real life" Parisian drunkard, and in 1861 The Spanish Singer became Manet's first Salon success. Here is a Parisian who is clearly play-acting as a Spaniard. His clothes are from different regions of Spain, and his guitar, strung for a left-handed player, is held in the right-handed position, rendering it unplayable - a prop. Manet reminds us of the inherent deception in paintings - that this is, after all, only a flat surface with an arrangement of coloured daubs of paint, which come together to represent a man playing a guitar.

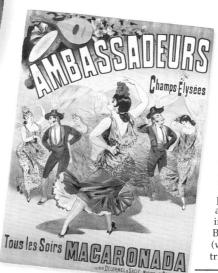

ARTISTS' HAUNT Spanish dancers were a favourite subject in popular illustration, and there were many venues, such as the Ambassadeurs Theatre, advertising this type of nightly entertainment. From 1862, the Mariano Camprubi dance troupe played two highly popular seasons at the Hippodrome. They played to an enthralled audience that regularly included Manet, Baudelaire, and Astruc (who planned Manet's trip to Spain in 1865).

LOLA DE VALENCE

1862; 123 x 92 cm (48½ x 36¼ in) Lola Melea, known as Lola de Valence, was the star of the popular Mariano Camprubi dance troupe from Madrid. Drawn as always to things new and modern, Manet saw in Lola de Valence the opportunity to paint a contemporary Spanish type. He entered this painting in the 1862 Salon, probably in the hope that he would benefit once more from the continuing Spanish vogue, but it was rejected.

DANCERS' FEET

This work (done in oil on parchment in 1879) is identical to a detail in Manet's watercolour, *The Spanish Ballet* (1862-63). He probably traced it, using this design as a basis for another in his series of painted tambourines (p. 18).

a S. M. la Reine & Copagne LOLA DE VALENCI	B
LULA Séréande	ZACHARIE ASTRI
Andonine	
	b, Ser un
har i travelar	La gri-la - rem ru-
1 22 a la r la r la r	e la la a la e la e la e la e la e la e

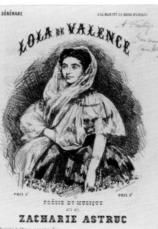

MUSIC SCORE This score for a serenade composed by Zacharie Astruc is an indication of Lola de Valence's popularity in Paris at that time. On the cover is a lithograph designed by Manet. The serenade is dedicated "to Her Majesty, Queen of Spain" and it first went on sale in March 1863 at three francs a copy.

CRUEL RECORD This spiteful caricature gives some idea of Manet's original composition (see below). He must also have been dissatisfied with the surrounding canvas, and it was not unusual for him to crop his paintings in this way (p. 26).

THE DEAD TOREADOR

1864; 76 x 153 cm (30 x 60¹/₄ in) At the Salon of 1864, Manet exhibited a multi-figure composition called *Episode d'un* Course de Taureaux ("Incident in a Bullfight"). All that remains of the original composition are two fragments that Manet himself cut from the canvas. The Dead Toreador (left) is one of these fragments, and the other was reworked by the artist to become The Bullfight (p. 36). There is a marked similarity in Manet's The Dead Toreador to The Dead Soldier, a painting then attributed to Velázquez. Manet had probably seen this work in the Pourtalès (a private collection in Paris) before he made his trip to Spain in 1865 (p. 36). The Dead Toreador was exhibited at Martinet's gallery in 1865.

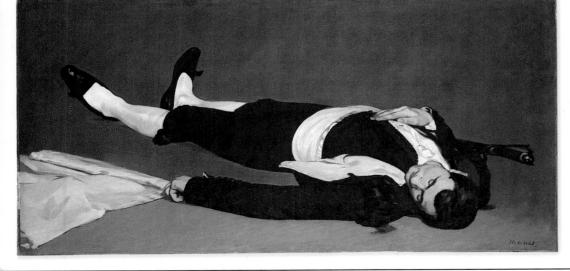

RIBBON The black neck-ribbon was Victorine's trade-mark.

Victorine Meurent

 $V_{
m ictorine}$ Meurent was Manet's favourite model. According to his friend Théodore Duret, Manet first met Victorine in 1862, "by chance in a crowd in a room in the Palais de Justice [and] had been struck by her original and distinctive appearance". She was then just 18 years old and had worked as a model in Thomas Couture's studio (pp. 10–11), although by that time Manet had already left. Victorine was known as a "fantastic character" who played the guitar and who could also paint (she later exhibited in the 1876 Salon when Manet's own works were rejected, and again in 1879). She was to enjoy a dubious kind of fame in her role as the naked courtesan Olympia (pp. 28–29), and the nature of the attention she received from the press, as Manet's model, attests to her strength of character and spirited independence.

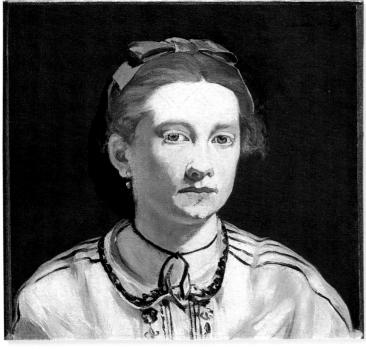

PORTRAIT OF VICTORINE MEURENT

1862; 43 x 43 cm (17 x 17 in) Victorine's distinctive colouring was perfectly suited to Manet's "blond" palette. This portrait is quintessential Manet, and is a good example of his habit of "flood lighting" his subject. As advice to a young painter he said, "In a figure, look for the full light, and the full shadow, the rest will come naturally". Manet's paintings were often labelled "flat", and his refusal to paint with half tones handicapped his career. His love of strong tonal contrasts and of the plastic qualities of paint distinguishes him from the Impressionists, who used broken colour and evenly distributed brushmarks.

This is a powerful and uncompromising portrait, and Manet's unflinching gaze is returned with equal equanimity from his model.

ashieres 31 Juilles 1883

Madame.

Excuster mai, je would en price, Si je viens jours' huis " arower with douleur or would the formant do cat in allout at the legather Mon heir Mount

Pares dance Sand annue darch que jai pala you un quaide partie de las tablerase, notammente-une l'Olynque, des chifteners. To tomes menotamment ortail bine comp sintered, at sitnit Soment que "I rendait his tableaved it me reterrorait me alifertions . J'clair lante jours alars stin boresants p partis pour l'amining.

Juan's jo mind, the Reased qui avoid sender on nametro de Sid lablance à the France me doits "I me revenant guelque chase . Je refudai, en le. it en ajout met que loseque je mail plus poter je tus sappetterait So Concept to at term bein plastel que ja re-dait : la dominio jois que ja ties de Honea de pour me faire antier il De Sormpos dema a ourrever deas un theater , ajoutine qu'il . Your dance

a is quite replace marine a requirer's word operations of texplans in our

A MODEL'S DECLINE

According to the writer, Tabarant, Victorine (left) posed for Manet "with long intervening lapses, for she had a will of her own". She went to America at the end of the 1860s, but returned to France in about 1872, and disappeared into oblivion. "That was the end. She soon took to drink.

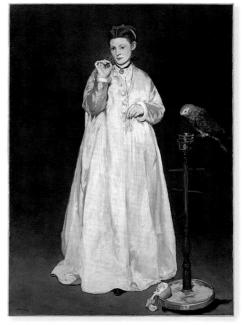

WOMAN WITH A PARROT

1866; 185 x 128 cm (72³/₄ x 50¹/₂ in) Manet's full-length portrait of Victorine is a triumph of dignified feminine grace. It was painted, very probably, in response to Courbet's (p. 29) overtly sexual, voyeuristic

> work on the same subject (exhibited at the 1866 Salon), and is executed with great subtlety and restraint. At the Salon this painting was entitled Young Lady in 1866.

in portuner on faces Dappelant mais la motheur a fonde pader of a completement à m more tent à fait in apable de ter un avoidne arrive a la ornar Diarte. alle") me pariou pour pluseered spice d'orcupation al 20 brainel Cast lette Schaltons de Super me determine a love sappeder to medi So to to and , A. Shan off at M. fu and pressure , and day que the hear at ninconcus - Cintintion de me teen an multimer, at en dos any to barne pender 3. hours interester but at de fron quelque chotes pour moi

plig , too dame , Sur mas profends to Franithez agrier .

Victorine Mouvents I bulwart to be suice . asmines. dem.)

PLEA FOR HELP

After Manet's death in 1883, Victorine wrote a rather moving letter (above) to his widow, describing how, years before, as Manet's model, he had offered her several paintings. Now, it seems, Victorine had fallen on hard times. Unable to earn a living and in need of some money, she hoped Mme. Manet would honour Manet's earlier promise.

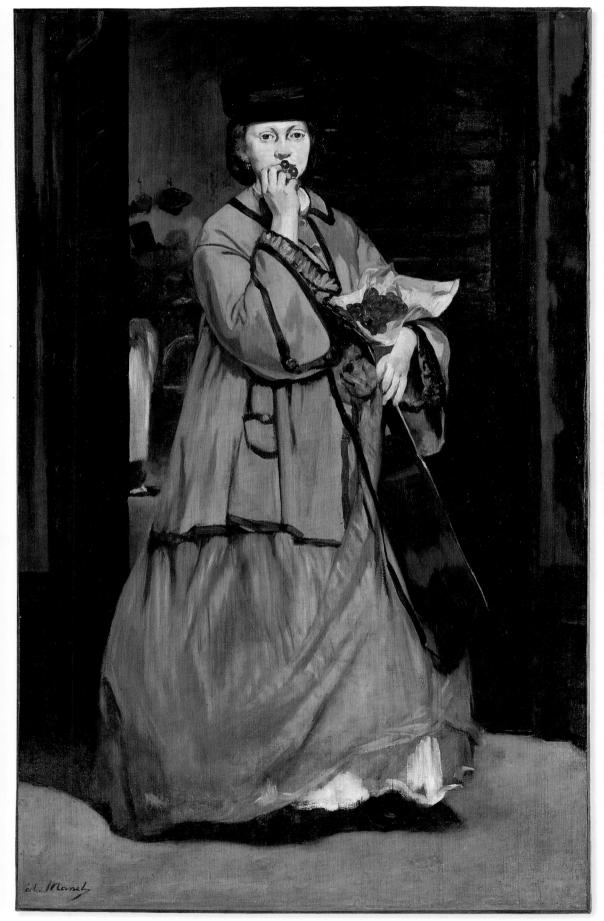

The Street Singer

1862; 175.2 x 108.5 cm (69 x 42¾ in)

Proust recalled walking with Manet one day when a woman, carrying a guitar, stepped out from a café: "Manet went up to her and asked her to come and pose for him. She went off laughing. "I'll catch up with her again," cried Manet, "and if she still won't pose, I've got Victorine." Manet's matter-of-fact treatment of this popular subject did not appeal to most critics, who preferred narrative and sentiment.

CRUDE APPEARANCE To its critics, *The Street Singer* appeared brash: its shapes over-simplified and its form lifeless.

PARIS CAFES It was obvious to contemporary viewers that Manet's *The Street Singer* was posed by a model. She is too fashionably dressed to accurately represent one of the many street entertainers frequenting the cafés of Paris.

STUDIO PROP The Street Singer's odd black hat was probably a studio prop of Manet's – it reappears in *Déjeuner sur l'Herbe*, this time on a man. This type of hat, the *faluche*, was traditionally worn by students.

KEY COLOUR Amidst the criticism levelled at Manet's *The Street Singer*, most critics failed to notice its beautiful greys and greens, or how the wonderful still life of cherries sets the slightly acidic colour key for the whole painting.

JUDGING PROCEDURE This cartoon is a parody of the system of rejection imposed by the panel of judges at the Salon each year.

so inundated with complaints that the Emperor himself went along to the galleries to view the rejected works. According to legend, he was unable to distinguish between the accepted and the rejected in terms of merit, so took the unprecedented step of ordering a separate exhibition for the rejected paintings, to run concurrently with the official Salon. Many withdrew, but Manet was one of the artists who took up the challenge, showing three paintings, including *Déjeuner sur l'Herbe*.

DANGEROUS ART

This caricature was a warning to unsuspecting art lovers – to keep their distance from such volatile work.

THE VOTING JURY

The jury consisted of 24 men, successful academic painters – all very conservative. They voted *en masse* (below), raising a hand or cane if they felt a painting worthy of acceptance. In 1863 Gustave Courbet (p. 25), who expected automatic entry to the Salon as a previous prize winner, had a painting barred by the Salon and the Salon des Refusés on grounds of immorality.

WHEN THE JURY rejected over 4,000 paintings from the 1863 Salon, there

was an outcry. The

government was

La FIN DU SALON. 1645 Le commissionnaire qui emporte les fableaux de M. Manet ayant commis l'imprudence d'oublier de les couvrir d'un voile.

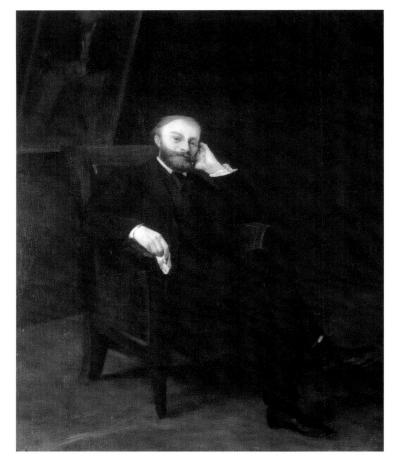

PORTRAIT OF EDOUARD MANET

Alphonse Legros; 1863; 61.5 x 50 cm (24¼ x 19¼ in) Alphonse Legros' small portrait of Manet also hung in the first Salon des Refusés, presumably near to Manet's own works as the paintings were arranged in alphabetical order by artist. Here we can see a philosophical and quietly defiant Manet. One can only imagine how the proximity of this selfassured presence would have served to add fuel to the many fires of indignation and disgust that surrounded his own works.

Salon of the rejected

HANGING PROCESS Inside the Palais de l'Industrie, where the Salon was held, pictures were hung from floor to ceiling, and the order of hanging decided at floor level in advance (right). There was a distinct hierarchy in play, which the public fully understood, and if a painting (particularly a small work) was "skied" (hung near the ceiling), there was little or no chance of it receiving any attention at all. This encouraged artists to produce canvases of enormous scale, which at the very least could ensure a certain amount of prominence.

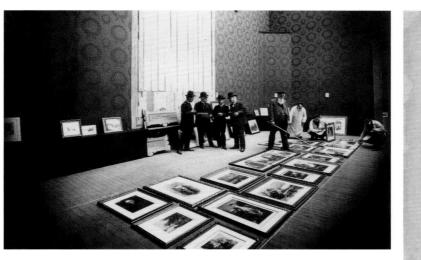

VICTORINE MEURENT IN THE COSTUME OF AN ESPADA 1862; 165.1 x 127.6 cm (65 x 50¼ in) This truly strange painting of Victorine Meurent dressed as a matador was one of three works Manet exhibited at the Salon des Refusés. It was hung alongside Déjeuner sur l'Herbe (pp. 24–25) and went largely unnoticed amidst the controversy surrounding that painting. Even so, this painting is a bold work - in placing Victorine in male clothing, within a bullfight setting, and a decidedly unusual composition that bears little relation to the main figure, Manet was taking risks. Indeed, the painting was seen as provocative by some critics. Manet owned a collection of Spanish costumes that were used in a number of his paintings, including this one and Young Man in Majo Costume (which hung the other side of Déjeuner sur l'Herbe at the Salon des Refusés).

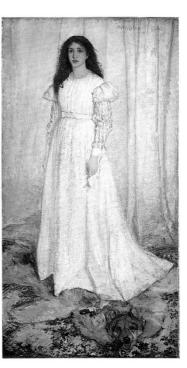

stècle; dessin. -- Portrait de madaune la baronne de M...; Luxa (Victor de), 6, rue Berri, Champs-Étysées. 54. – Chasseurs d'Afrique, 35. – Pièces en batterie. con (modame), née Marie Deherain, née à Pa-s, élève de Decaisne et Ary Scheffer, 10, ruc de Duras, 256. — L'Enfant pieux, d'après Ary Scheffor, 257. — La Viergo et l'Enfant Jèsus, d'après Raphaei, 258. — Portrait de mademoisolle C. D... MALLET (J.), rue de l'Université, 54. 339, — Le 24 septembre (852 à Viviers d'Ardèche 360, — Les Pilotes-Mendaires du Rhône. 364. — Le Christ dans les blés.

MAMLET-VERNON (Jules), à Creil (Oise), route de Ne gent les Vierges, élève de M. Amédée Faure e Lagentin

- Un peintre étadiant une tête de

- Le Bain.

CATALOGUE

DES OUVRAGES

REFUSÉS PAR LE JURY DE 1865

- 30. - 40ana homme on continue d'Asia,
365. - Madamielle V., en continue d'Asiada.
Musses (E), dére de M. de Badder, quai de I tume, Ej.
366. - Portrait de M. R. M.
367. - Portrait de malane J. D.
369. - La Saltarello.
369. - La Ballage.
<li 375. La Groix printannière
 Tête de femme dans u dans une co Acee de l'emme dans une couronne.
 MArmosar (Aloxis), 21, rue de l'Église Grand-Mont-rouge, et 448, rue de Grenelle-Saint-Germain.
 Paradis perdu.
 Poriraii de mademoiselle P. p.

lle F. B

ORIGINAL CATALOGUE

When the Salon des Refusés opened to the public on 11 May 1863, 7,000 visitors attended on the first day. This huge public interest contrasted sharply with the almost complete absence of serious critical attention that the exhibition received.

THE WHITE GIRL

James Abbott McNeill Whistler; 1863; 76.5 x 51 cm (30 x 20 in) This painting, by the American artist, Whistler, caused almost as much of a sensation at the Salon des Refusés as Manet's Déjeuner sur l'Herbe, and was probably influential in Manet's own attempt at a "white" painting two years later (p. 27).

A bourgeois scandal

 W_{HEN} Déjeuner sur l'Herbe ("Luncheon on the grass") was first shown to the public at the celebrated Salon des Refusés in 1863 (pp. 22–23), it caused an outcry. What upset the critics most was Manet's audacity in "quoting" the Old Masters, tarnishing timehonoured themes by parading vulgar modern counterparts in their place. These were not nymphs and shepherds of myth and legend, but modern Parisian city dwellers indulging their petitbourgeois passion for picnicking in the country. Manet further exasperated the critics by the ambiguity of the painting's title, which gave no explanation as to why the woman was naked and the two men fully clothed. In reflecting Manet's concern with the painted surface, Déjeuner sur l'Herbe pre-empts the "art for art's

sake" stance of 20th-century modern art. On seeing the painting, the Emperor reputedly dismissed it as obscene, and cartoonists and writers for the popular press had a field day. Few serious critics came to Manet's defence and Déjeuner *sur l'Herbe* became the *"succès de scandale*" of the exhibition.

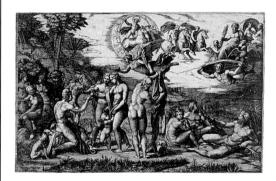

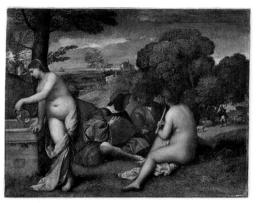

PASTORAL CONCERT Titian; 1576; 110 x 138 cm (43¼ x 54¼ in) According to Antonin Proust, it was Manet's intention to "re-do" Titian's Pastoral Concert (then attributed to Giorgione). Manet has translated this classical scene into a contemporary setting, uniting the ancient and modern worlds to reveal a modern tradition.

JUDGEMENT OF PARIS (AFTER RAPHAEL) Manet directly copied the three figures on the right of this engraving by Marcantonio Raimondi for the figures in Déjeuner sur l'Herbe. This partly explains the puzzling gesture of the reclining man in Manet's painting.

PREPARATORY STUDY Victorine Meurent (pp. 20–21) was the model for the seated nude in this study for Déjeuner sur l'Herbe. She is recognizable by her red hair subdued to brown in the final work. Both Manet's brothers, Eugène and Gustave, posed for the seated man to the right of the canvas, and Ferdinand Leenhoff (the brother of Suzanne Leenhoff) was the model for the remaining figure.

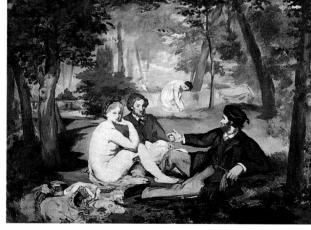

Déjeuner sur l'Herbe

1863; 208 x 264 cm (82 x 104 in)

The lack of explanation of this strange scene made it totally incomprehensible to most contemporary viewers. Manet may have wished to out-do his older rival Gustave Courbet (right), who had already scandalized the public with his realism, and was seen to exceed the bounds of decency (and undermine social values). Courbet however, in depicting a naked woman at ease in the company of clothed men (p. 25) had painted a "legitimate" contemporary nude – the professional life model – whereas in this self-consciously modern painting the woman's nudity is an enigma.

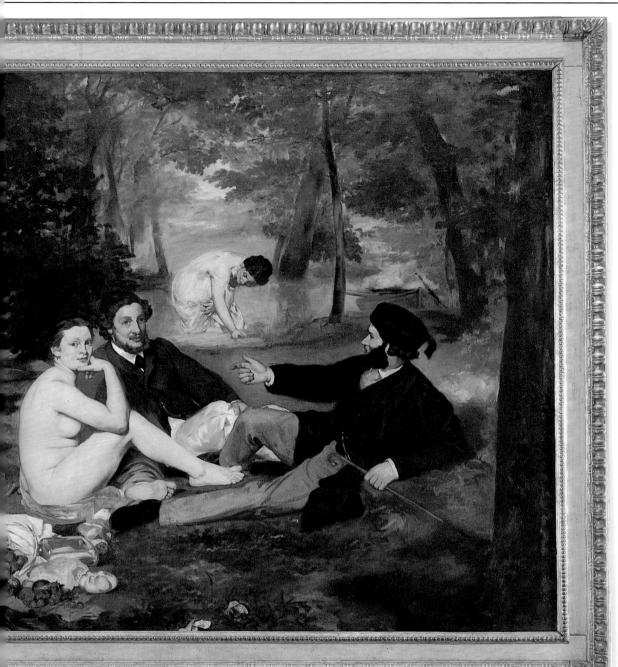

CHEROLOGICAL CALLER CALLER CALLER CALLER CALLER

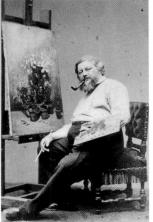

GUSTAVE COURBET

Proud of his peasant stock, and largely self-taught, Courbet was anti-intellectual, passionate, and brash, and believed in painting only "real and existing things".

> THE ARTIST'S STUDIO Gustave Courbet; 1854-55;

361 x 598 cm (1424 x 235½ in) Courbet's huge canvas – 3.6 metres (12 feet) high by 6 metres (20 feet) long – was an immensely ambitious work, containing 28 figures. When this painting, together with A Burial at Ornans, was rejected from the Exposition Universelle of 1855, Courbet exhibited it in his own pavilion, an unorthodox move that Manet imitated in 1867.

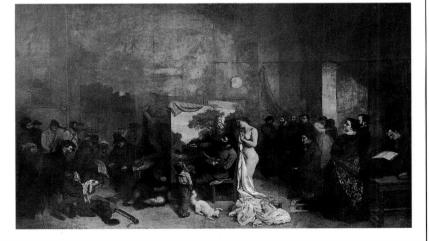

A STUDIO PAINTING Déjeuner sur l'Herbe was painted entirely in Manet's studio, and he makes no pretence of that fact. The landscape, however beautiful, is artificial and painted as a backdrop: a stage set for the figures. The space is shallow and enclosed, with only a tiny patch of sky to suggest a far horizon.

SPATIAL GAMES There is an odd distortion of space in the relation between the bathing woman and the main group. Considering the distance implied by the receding trees and perspective of the river, she appears giant-like, particularly in proportion to the small boat moored just a few feet away.

CONTEMPORARY STILL LIFE The clothes and fruit "negligently" scattered on the ground not only add colourful accents to the overall green-brown of the painting, but set the scene firmly in the modern world. The elegance of the clothes suggests worldly sophistication and self-conscious style.

HUMOROUS TOUCH Hidden in the grass, in the bottom left-hand corner of the painting, is a well-camouflaged frog. It has a less earth-bound companion in the finch, flying over the group, almost central to the composition.

Suzanne Leenhoff

MADAME MANET Suzanne Leenhoff was plump, good natured, and easy going. She may have seemed an unlikely partner for the urbane Manet but the couple enjoyed an affectionate relationship.

THE ILLEGITIMATE CHILD Léon was 11 when Suzanne and Manet married, and had grown up in the Manet household.

I and the second second

and a mark for the form of the second for the second secon

A YEAR AFTER THE death of his father in 1862, Manet married Suzanne Leenhoff, a figure he would paint throughout their relationship. Their affair had begun soon after Manet's return from Rio de Janeiro in 1849 (p. 7) when Suzanne, as piano teacher to his brothers, was living in the family home. Eight years before their marriage, Suzanne went to Holland: she returned with a baby boy. This was Léon, her illegitimate son who was passed off as her younger brother. Some assume Léon's father was Edouard Manet, but the absence of any other children after his marriage to Suzanne – coupled with the knowledge that Edouard had contracted syphilis early on, and was probably

infertile – makes this unlikely. It is possible that Edouard's father, Auguste, was Léon's father, hence the great secrecy that surrounded the child.

A DUTCH WEDDING

As the marriage register (below) shows, Edouard and Suzanne were married on 28 October 1863, at Zalt-Bommel in Suzanne's native Holland. The couple spent a month there after their wedding before returning to Paris. Manet loved Dutch art, and made several trips to Holland where he could study the paintings of Hals, Rubens, and Rembrandt.

EDOUARD MANET News of Manet's marriage came as a complete surprise to many of his friends. He had kept his affair with Suzanne (well over 10 years long) largely secret.

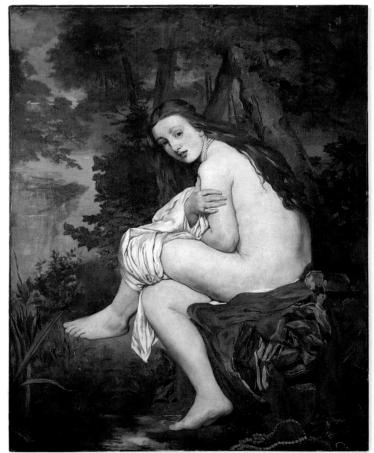

THE SURPRISED NYMPH

1859–61; 146 x 114 cm (57½ x 45 in) Suzanne posed for *The Surprised Nymph* four years before her marriage to Manet. An early example of Manet's virtuosity, this painting was inspired by several sources, notably Rembrandt's *Bathsheba* and Boucher's *Diana at the Bath*. The figure was also based on engravings after paintings on the theme of Suzannah and the Elders, including a lost version by Rubens. This single nymph was originally part of a larger canvas: *The Finding of Moses* (1858–60), from which Manet cut this powerful image of vulnerable nudity.

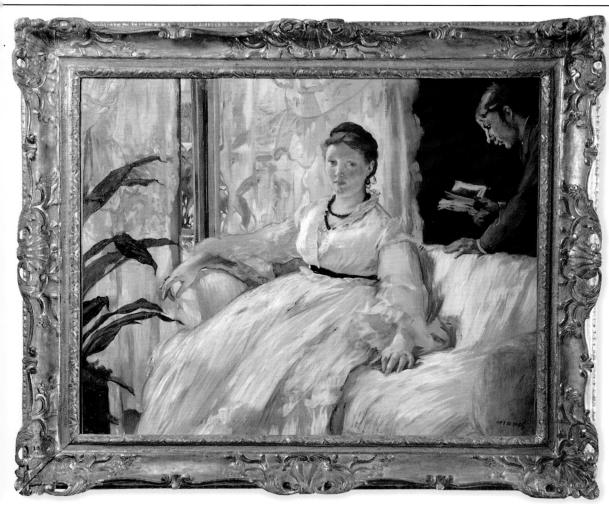

READING

1865–73; 61 x 74 cm (24 x 30 in) Originally a single figure portrait of Suzanne, Reading was begun in 1865. The figure of her son, Léon, was added several years later, which explains the apparent age-gap anomaly. It is an affectionate portrait of great delicacy. Suzanne's solid flesh and powerful, expressive hands radiate warmth amidst the range of cool whites and greys. The interplay of white on white suggests Manet was influenced by J.A.M. Whistler's The White Girl (1863, p. 23).

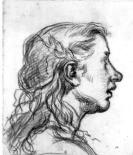

DRAWING OF SUZANNE This powerful chalk drawing shows a youthful Suzanne Leenhoff, probably seated at the piano.

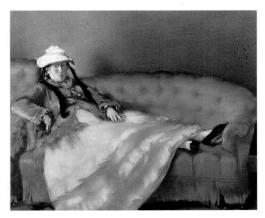

MADAME MANET ON A BLUE COUCH 1874; 65 x 61 cm (25½ x 24 in); pastel on paper This later portrait of Suzanne shows her dressed in outdoor clothes and wearing the bonnet with black ribbons that Manet painted many times. The saturated colour is unusual in Manet's work and it is remarkable for its jewel-like quality.

MADAME MANET AT THE PIANO

1868; 38 x 46 cm (15 x 18 in) Manet was proud of Suzanne's talent. The daughter of an organist, she was herself a quite brilliant pianist. In this small, and beautifully subtle portrait, where the pink of her cheek is set off against the grey of the wall, Manet has caught the rapt, selfcontained expression of the pianist.

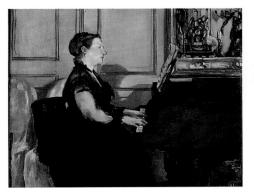

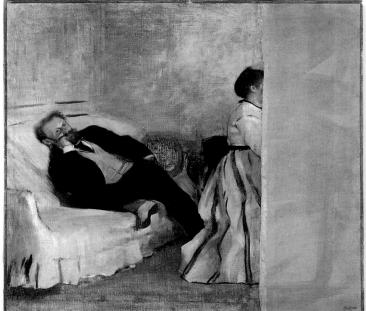

EDOUARD AND MADAME MANET Edgar Degas; 1868–69; 65 x 71 cm (25½ x 28 in) There was a temporary rift in Manet's friendship with Degas when Manet performed what can only be described as an act of vandalism on this family portrait, given to him by Degas. Unhappy with the way Degas had painted his wife's profile, Manet simply cropped the canvas. Two years later, he painted his own version of Suzanne in profile (left).

A new controversy

A FTER THE PUBLICITY GENERATED by the Salon des Refusés in 1863 (pp. 22–23), the judges for the official 1865 Salon were cautious about rejecting too many works, and *Olympia* was accepted. Again, Manet outraged the public and critics. It is difficult to understand today why *Olympia* was so shocking when, on the surface, it appears a formal nude within the long tradition of the nude in Western art. Olympia's power lay in her gaze: whereas many contemporary nudes were portrayed as either anonymous nymphs or mythical figures – tacitly

understood to be courtesans – Manet painted a courtesan as a courtesan, and her resolute gaze defies question of that role.

Olympia

1863; 130 x 190 cm (51 x 74³/₄ in) What made Olympia doubly disturbing was her very real identity that of Victorine Meurent. She was well known for her strong character (pp. 20-21) and Manet, who said of the painting, "I painted what I saw" has unavoidably captured her spirit. Olympia's hand presses down on her thigh, thereby hinting at Victorine's awareness of her own nakedness, and simultaneously at the courtesan's knowledge of the power of her sex.

OLYMPIA'S "CLIENT" Olympia's gaze further unsettles as she confronts us – who, as spectators, must assume the role of potential client.

> THE BLACK CAT Manet has replaced the peacefully sleeping dog in Titian's *Venus of Urbino* (p. 29) with a bristling and vaguely sinister black cat.

SEXUAL DRESSING Victorine's characteristic neck ribbon, as her only piece of clothing, hints at a wrapped luxury awaiting purchase.

RECLINING NUDE

In the more modest pose of this chalk drawing, we can see an earlier idea for the, as yet unrealized, figure of Olympia. In this version, drawn three years before Manet painted *Olympia*, she toys with the end of a plait of hair, and her attitude is altogether more playful. In concentrating solely on resolving the figure, Manet has left the face totally blank; nevertheless, Victorine's compact proportions are clearly recognizable in these bold single lines.

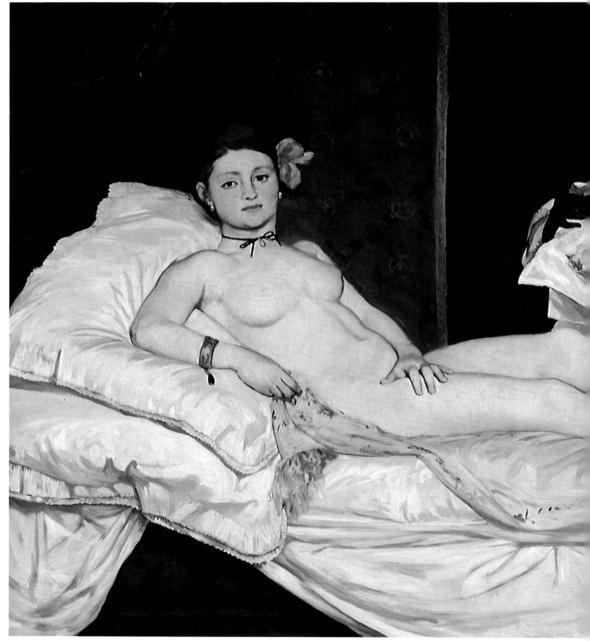

VENUS OF URBINO Titian; 1538; 119 x 165 cm (46³/₄ x 65 in) Manet took the basic composition of Olympia directly from Titian's Venus of Urbino; and Victorine Meurent adopted the classical pose of a reclining Venus. The similarities with Titian's Venus end here however, and in place of his rather coy, passive goddess is a coolly self-assured Olympia. No longer Venus in the guise of the courtesan, but the courtesan triumphing as a modern Venus.

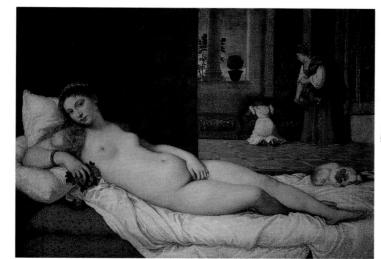

RIDICULED PAINTING

In addition to the hostile reaction of critics, (so strong that the painting was moved to the far end of the exhibition), *Olympia* provoked shocked, embarrassed laughter from the public. Bertall's caricature, depicting a grubby-looking Olympia with steaming feet, is representative of the ridicule the painting received from the press.

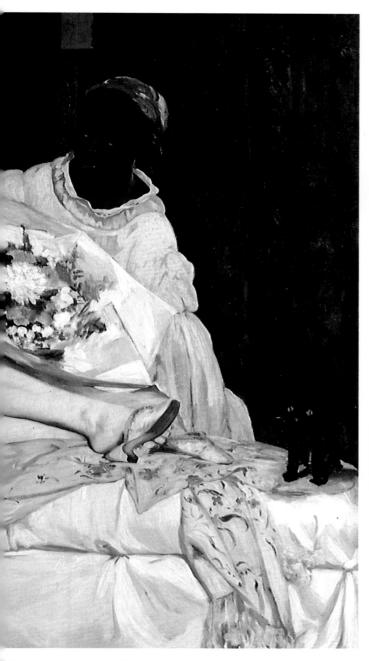

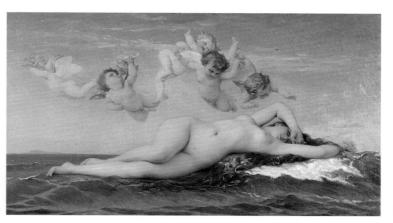

NEW SUPPORT Emile Zola's booklet (above) publicly defended Manet and his art. In thanks, he later painted the writer's portrait (p. 37).

ACCOMPANYING POEM "When, tired of dreaming, Olympia awakens, Spring enters on the arm of the mild black messenger." These are the first lines of a poem about *Olympia* by Manet's friend, Zacharie Astruc, who describes her as: "The august young woman in whom ardour is ever wakeful."

lumpia

The print engre on the "ar bray to done or Cast Verelange ha mit an on one of the operation of the operation

Sansantre verese, Olympia chan de benez grez vont charlen des s da fassim d'accouple an leunie, baite sa va cetta pa-emganece tra qu'alle acquitte et a qu'alle

Ob' Sen view to syntax of and dive ton course relating flotte at the gaels marries semisch foren Dui motiver l'attrait a lie A atta bourse en flow deut

Ou proof to a const of each. Atte in Doline van a the atte hagener Villante of allers took toops righter of so Controle velopte is there goes and

Then the bain, porfice any assumed mentage of the faits du Sandreits en chard film de bankpurst of pran assured de te gaden bei sent thebante aspart to nis de te gaden bei sent to marie aspart for nis de rais konsen ned beneet

Astruc

BIRTH OF VENUS Alexandre Cabanel; 1862;

130 x 225 cm (51% x 88% in) In contrast to the provocative realism of Manet's Olympia, Cabanel's Birth of Venus (purchased by Napoleon III at the official 1863 Salon) is a voyeuristic fantasy. Her unnaturally white, hairless body is as vulnerable and unthreatening as a baby's, and with her arms partially obscuring her face, she is safely anonymous.

An elegant realism

 $M_{
m ANY}$ of Manet's still lifes were painted as gifts for his friends and supporters. He gave White Peonies and Secateurs to his friend, the realist writer and critic, Champfleury; the "careless" arrangement of this realist still life, with its addition of a pair of secateurs, would have been appreciated by the critic. The painting reveals Manet's pure, unadulterated mastery of paint. The modest scale, composition, and subject matter allow us to see Manet as painter, first and foremost – unencumbered by more complex pictorial issues. With generous, fluid brushstrokes, he has captured the intrinsic qualities of leaf and petal, whilst simultaneously drawing our attention to the physicality of the paint.

Viridian

Lead white

Ivory black

MATERIALS

The secret of this small painting's power lies in part in Manet's greatly restricted palette. In effect, the composition consists of three colours: the warm brown ochre of the empty background; the deep green of the partially obscured foliage; and the warm whites of the flowers, painted in high relief and in sharp contrast to the rest of the canvas.

White Peonies and Secateurs

1864; 31 x 47 cm (12¹/₄ x 18¹/₂ in)

The virtuoso brushwork of this painting reveals Manet's affinity with the grand master of still life, Jean-Baptiste Chardin (p. 32). In 1763, Diderot wrote this appreciation of Chardin's (only surviving) flower painting, which could happily apply to Manet: "This is unfathomable wizardry. Thick layers of colour are applied one upon the other and seem to melt together. Draw near and everything flattens out and disappears; step back and all the forms are re-created."

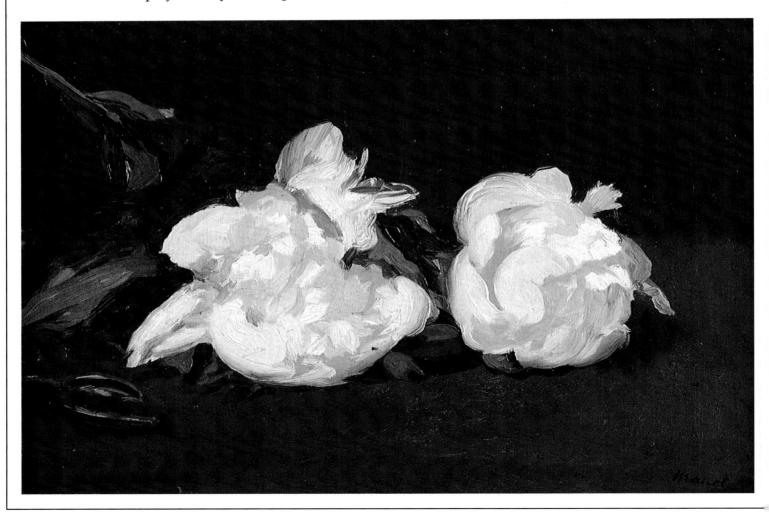

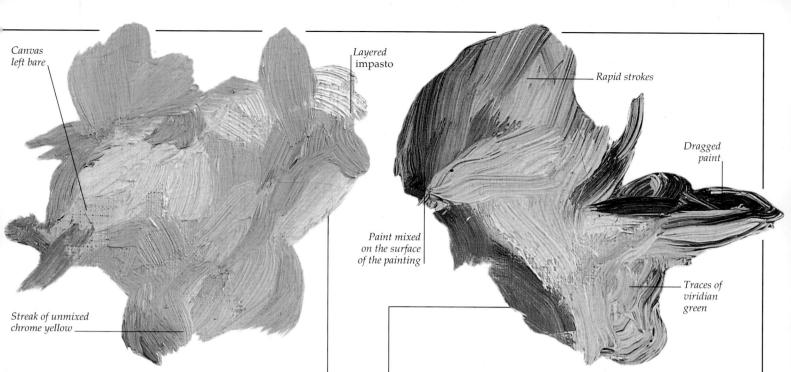

HEART OF THE FLOWER Manet simulates the tightly clustered inner petals with an inspired play of impasto with transparent pigment, over the flatness of the canvas – still visible in bare patches. He has created a physical, three-dimensional paint structure, made up of layers of short, spiky brushstrokes. These catch the natural light falling on the canvas, and by projecting physically from the smooth, empty background, they serve to make the flower head all the more "real".

ENERGETIC BRUSHWORK In this animated detail we can see Manet's instinctive manipulation of the paint's surface. He has mixed the colours on the actual canvas, dragging the dark brown-black of the background into the white of the petal to create shadow and give solid definition to the bloom. His brushwork is applied rapidly, with great energy and spirit, and his experience and understanding of the medium are clearly obvious. One can really sense his enjoyment of the paint.

Fluid brushwork

Thin layer of

Dense opaque paint

CAPTURING FORM This detail can be seen as representative of Manet's direct, intuitive response to form. He was able to create form with the bare minimum of strokes, striving always to preserve the freshness of the first marks in his finished paintings. This apparent spontaneity, however, is the result of constant scraping off and re-working of the surface.

Sharp-edged definition

'Thick" over "thin" build up of paint surface

SPEAR OF GREEN

The foliage plays a secondary role to the brilliance of the flower heads. The dark, sombre greens dissolve completely into the background at times, allowing the pale whiteness of the blooms to dominate the canvas. Where the foliage has more definition, it serves to support the structure of the composition, so that the flower heads do not "float" in the empty space of the background. The leaf in this detail is painted in one or two bold, thick strokes.

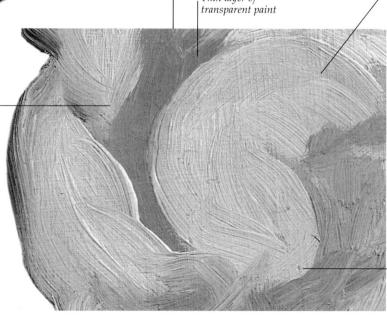

The still life

MANET WAS A MASTER of the still life, from tiny works of great dignity, to large complex arrangements in the 18th-century Dutch and French tradition. The still-life elements of his larger compositions also play a

crucial role, functioning as separate, sometimes dislocated, "messages". Manet often used the still life as a prop – such as the oyster shells artfully scattered at the feet of *A Philosopher* (pp. 38–39) or the unplayable guitar in the hands of his Parisian *Spanish Singer* (pp. 18–19) – to remind us that painting is, after all, a deception. Another important function is its affirmation of contemporary reality: for instance, the beautiful still life of clothes of contemporary Paris fashion in *Déjeuner sur l'Herbe* (pp. 24–25) insists on an un-historical, un-mythological interpretation of the scene.

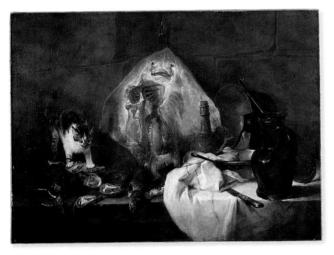

THE RAY FISH

Jean-Baptiste Chardin; 1726; 114.5 x 146 cm (45 x 57½ in) Chardin was born in Paris in 1699. The son of a carpenter, he became an Academician in 1728 after he had attracted attention with The Ray Fish. He spent his career, spanning 40 years, in the production of still lifes and domestic interiors, which expressed a world of simplicity, dignity, and order. The cat, bristling and arching at some unseen presence in The Ray Fish, re-appears in Manet's painting, Olympia (p. 29 & detail, bottom left).

Still Life with Carp

1864; 73.4 x 92.1 cm (29 x 36¼ in) The year 1864 saw the advent for Manet of a phase of still-life painting that was largely influenced by one of the great French painters: Chardin. Due, in part, to a major exhibition of his work at the dealer Martinet's gallery in 1860, Chardin was enjoying something of a revival. Manet was able to see over 40 works by Chardin, and would have recognized, in their rich, brilliantly textured brushwork, a spirit close to his own. With his Still Life with Carp, Manet emulates, and borrows certain stylistic devices from Chardin, such as the knife protruding from the picture plane and the diagonal composition. Like Chardin's magnificent Ray Fish, Manet has captured the glistening, muscular body of the fish which, although dead, exudes life.

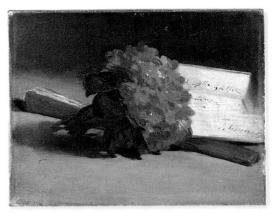

BOUQUET OF VIOLETS 1872; 22 x 27 cm (8% x 10% in) Manet painted this small, delicate still life in thanks to Berthe Morisot for posing for her portrait (p. 49), in which she wears a bunch of violets at her throat. Manet has used the device of a little note to sign and dedicate the painting to her.

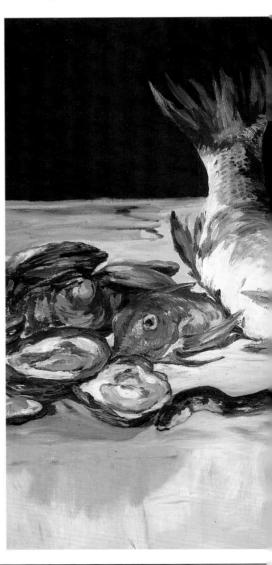

Violets

STARTLED CAT *Olympia*'s cat (p. 29) bears a marked resemblance to the startled cat in Chardin's *Ray Fish*.

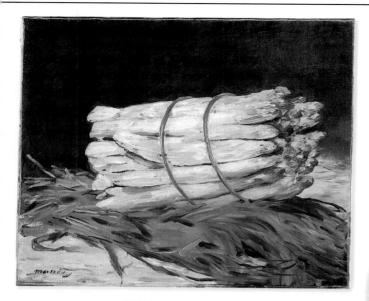

BUNCH OF ASPARAGUS 1880; 46 x 55 cm (17⁴x 21¹/₂in) Considering its modest subject, this is a large canvas. The out-size bundle of asparagus is painted with such vitality and sheer love of paint that it could stand for Manet's entire *oeuvre*. It exhibits his enduring love of strong contrasts; and how he used black as a foil for colour, and achieved the strange pale luminosity peculiar to white asparagus. THE ASPARAGUS 1880; 16 × 21 cm (6¼ × 8¼ in) The story behind this work does much to endear Manet to us. He had sold the Bunch of Asparagus (left) to Charles Ephrussi, editor of the Gazette des Beaux-Arts, for 800 francs. Ephrussi sent 1000 francs instead, so Manet painted this tiny canvas and sent it to him with a note: "There was one missing from your bunch."

THE HAM

1875–78; 33 x 42 cm (13 x 16½ in) Manet said: "The still life is the touchstone of painting." For two centuries still lifes such as *The Ham* had been regarded by French academics as the poor relative of all the other genres. The increased output of still lifes during the 19th century was felt as a threat by the academics – who had awarded history painting the highest position within their hierarchy, and still life the lowest. The photo (left) shows Degas with *The Ham* hanging on his wall.

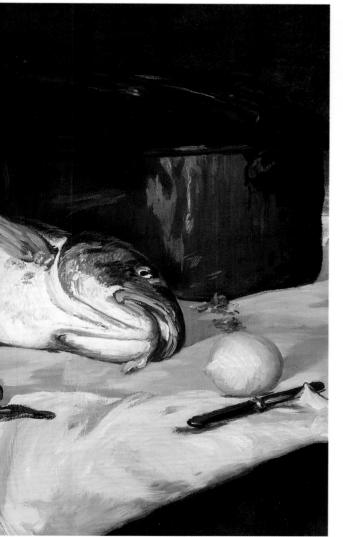

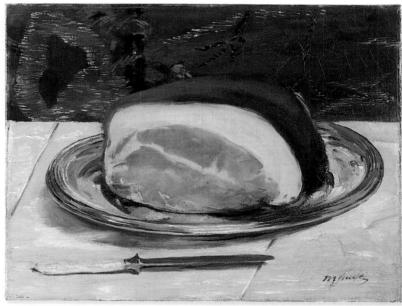

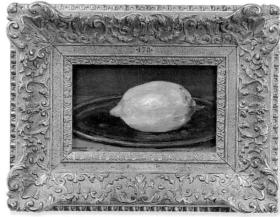

THE LEMON

1881; 14 x 21 cm (5½ x 8¼ in) Manet told the painter Georges Jeanniot, "Concision in art is a necessity". It would be difficult to find a more concise painting than this. Manet understood well the power of economy of line, and produced masterpieces of understatement such as his portraits of Berthe Morisot (p. 46), Victorine Meurent (p. 20), and the truly magnificent Fifer (p. 41).

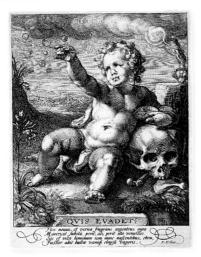

"WHO CAN EVADE IT?" The verse accompanying Hendrick Goltzius' engraving (1594) on the "Vanitas" theme reads: "The fresh, silvery flower, fragrant with the breath of Spring, withers instantly as its beauty wanes. Likewise, the life of man, already ebbing in the newborn babe, disappears like a bubble or like fleeting smoke."

SOAP BUBBLES

Jean-Baptiste Chardin; 1733; 93 x 74.5 cm (361/2 x 291/4 in) Chardin (p. 32) took this theme of a boy blowing bubbles from Dutch 19thcentury "Vanitas" paintings, in which the bubble was a common symbol for the brevity of life. Chardin's Soap Bubbles is a dignified, almost solemn work that was a departure from the generally light-hearted depictions of the subject, and it inspired Manet's painting on the same theme. Chardin worked slowly and painstakingly, and would often duplicate successful images. He made several close copies of this painting.

The cycle of life

ONE OF MANET'S FAVOURITE flowers was the peony, which had entered Europe from China early in the 19th century. Manet grew peonies in his garden and in 1864 he painted them at least seven times – their large blooms and loose structure were well suited to his generous brushwork. *Peonies in a Vase* is the definitive work from the series he produced that year. There is very little symbolism or narrative in Manet's work, a factor that contributed to his continued rejection by traditional critics and Salon juries (p. 21). Where he chose to paint a subject that was traditionally loaded with symbolic interpretations, he either allowed the naturally inherent "meanings" – found, for instance, in dying flowers (right) – to speak for themselves; or, he stripped the subject of its symbolic meaning, reducing it to its workaday role, as in *Soap Bubbles* (below,

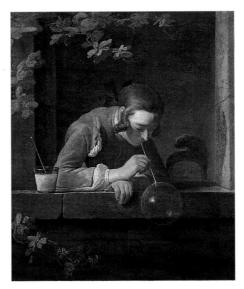

left). *Peonies in a Vase* is a subtle reworking of the 17th-century Dutch tradition of "Vanitas" paintings – allegories on the themes of death and the brevity of life.

PORTRAIT OF EVA GONZALES 1870; 191 x 133 cm (75¼ x 52¼ in)

In 1869, Eva Gonzalès became Manet's first and only pupil. She is portrayed here according to the custom for depicting women artists – in her Sunday best, "posing" as a painter. Manet later painted her really at work, swathed in an apron.

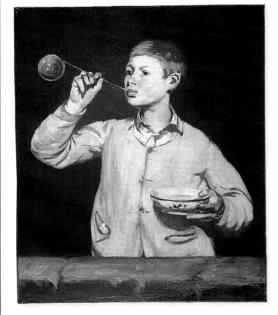

SOAP BUBBLES

1867; 100.5 x 81.4 cm (39½ x 32 in) Manet was inspired as much by Chardin's naturalistic treatment of this theme as by the subject. Manet's painting is devoid of moral sentiment. It is, rather, a portrait of a 15year-old boy, Léon Leenhoff (pp. 26–27), caught in the complete absorption of his task. Like Chardin, Manet's strength was in stillness rather than action, and he has chosen to portray the same, still moment of precariousness. Manet had recently seen Chardin's Soap Bubbles, and this, together with the memory of Couture's own sentimental version of 1859, probably induced Manet to honour the Old Master and challenge his old teacher (pp. 10-11) with his new version.

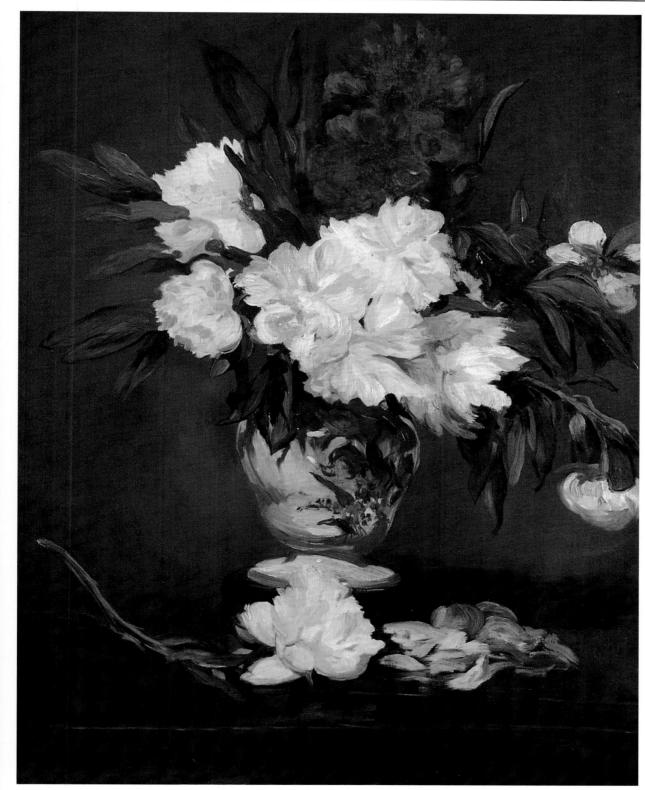

STAGES OF GROWTH Peonies in a Vase can be interpreted in a cyclical fashion, starting with the fresh, buoyant leaves and immature blossoms on the left, moving across to the fullblown pale pink blooms, which are surmounted by two climactic blood-red peonies.

DYING FOLIAGE From the highest point of dark red, the direction shifts round further, with a sweeping movement, to the heavy stems on the right, which are collapsing under their own weight. The leaves droop and the flower heads hang upside-down.

FALLEN PETALS The sequence ends with the pile of petals, which have dropped onto the table top, beneath the vase. Their beauty is gone and they are already beginning to discolour: a reminder of the physical reality of death.

LIFE RENEWED Life and death appear together at the foot of the vase: the dropped petals on the side of death, and the freshly cut blossom whose arching stem takes our gaze back to the beginning of the cycle, on the side of life.

Peony from *Portrait* of Eva Gonzalès (left).

A COPY Manet appears to have made a direct copy of the peony from his earlier painting (above).

Peonies in a Vase

1864; 93.2 x 70.2 cm (36³/₄ x 27³/₄ in)

"What a painter! He has everything, an intelligent mind, an impeccable eye, and what a hand!" – Paul Signac. Even Manet's harshest critics couldn't deny his technical dexterity and the sensual, painterly qualities of his flower paintings. Manet was well aware of his technical skills and his talent, and contrary to the often radical appearance of his work, he was constantly surprised by its rejection.

Spain and Japan

PABLILLOS DE VALLADOLID Diego Velázquez; 1632–34; 209 x 123 cm (82¼ x 48½ in) Manet wrote of Velázquez's portrait of the actor Pablillos in the Prado, Madrid: "It is perhaps the most astonishing piece of painting ever done."

At the END of Autumn 1865, Manet set off for Spain. He travelled alone, with an itinerary planned for him by his friend Zacharie Astruc (p. 19). The reason for his trip was to see the works of the great Spanish masters that Manet had for so long admired at second hand: Goya, El Greco, and above all, Diego Velázquez. Manet returned to Paris with a more significant understanding of Velázquez's genius, which he translated into

his own works, initially in a series of full-length portraits (pp. 38–39). In his *Portrait of Emile Zola*, Manet acknowledges his debt to Velázquez, as well as his enthusiasm for contemporary Japanese art, at that time still relatively new to France.

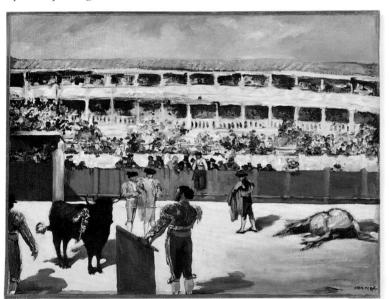

BULLFIGHT

1865–66; 48 x 60.4 cm (19 x 23¼ in) To Astruc's astonishment, Manet returned from Spain after only ten days, hating the food and climate. Manet had attended several bullfights, and made sketches that he later developed into paintings, such as this festive work; oddly lighthearted despite its bloody subject.

WITNESS TO A SPECTACLE Manet described the bullfight as "one of the finest, most curious and most terrifying sights to be seen".

LAS MENINAS Velázquez; 1656; 318 × 276 cm (125% × 108% in) Manet's admiration for Velázquez led him to award the master the ultimate accolade of "Painter of Painters".

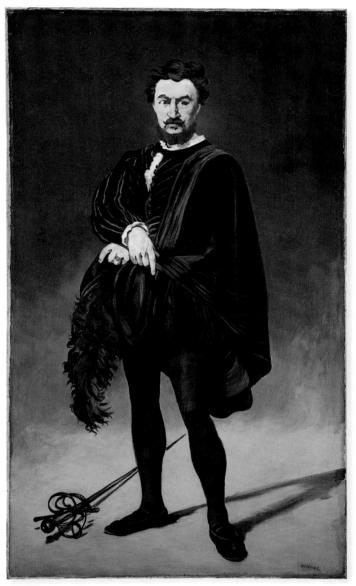

THE TRAGIC ACTOR

1865–66; 187.2 x 108.1 cm (73½ x 42½ in) Manet painted this portrait of the brilliant tragedian, Philibert Rouvière, in the role of Hamlet, soon after his return from Spain. It is the first of Manet's paintings in which his newly-made discoveries were put into action, and we can see the direct references he made to Velázquez's *Pablillos de Valladolid* (above).

EMILE ZOLA AND JAPAN Zola was an avid collector of *Ukiyo-e* prints – the Japanese equivalent of realistic art. His home was filled with Far-Eastern *objets d'art*, and the Irish writer George Moore recalled seeing prints "of furious fornications ... a rather blatant announcement of naturalism".

THE WRESTLER ONARUTO NADAEMON OF AWA PROVINCE Japanese prints, such as this one by Kuniaki II, had entered Europe in the middle of the century, but Japanese art made its first real impact in France at the Exposition Universelle in 1867. Manet was an early collector, attracted by the bold simplicity of the drawing and the flat areas of bright colour that were especially characteristic of Nishiki-e prints.

JAPANESE ILLUSTRATIONS This is a page from *The Manga*, a book of illustrations that ran to 15 volumes, containing thousands of studies of animals, plants, fish, insects, and people going about their everyday life. It was the work of the great 19th-century Japanese artist, Katsushika Hokusai, and his brilliant woodcuts drawn directly from nature are executed with humour, modesty and incredible clarity of observation.

PORTRAIT OF EMILE ZOLA 1867–68; 146 x 114 cm (57½ x 45 in)

Manet's portrait of Zola is an essentially "Japanese" work, achieved with the aid of exotic props and, more significantly, by its pictorial organization: the shallow space, silhouetted figure, and strong decorative elements of repeated flat shapes, and rectangles parallel to the picture's edge. It is also a statement of Manet's eclecticism: Japan and Spain appear together (represented by Kuniaki's wrestler, above, and Velázquez's *Little Cavaliers*), framed above the desk, and joined by Manet's *Olympia*, itself a hybrid of old and new. The open book is Manet's copy of Charles Blanc's "Histoire des Peintures" – a valuable source of older art for Manet.

MNR Fol. 17

JAPANESE WOODCUT Manet has lifted a detail straight from the page of plants and flowers from Hokusai's *Manga* (above, right) and has only altered it slightly for the *ex libris* page of Mallarmé's poem (right).

"AFTERNOON OF A FAUN"

Manet worked on several collaborations with his friend, the symbolist poet, Stéphane Mallarmé. In addition to illustrating Mallarmé's own work (right), Manet produced a series of lithographs for Mallarmé's translation of Edgar Allan Poe's "The Raven" and "The Poems of Poe", sharing Mallarmé's enthusiasm for the American writer.

Beggar-philosopher

MANET HAD GREATLY admired Velázquez's imaginative portraits of the philosophers Aesop and Menippus in the Prado, Madrid, in 1865. He wrote to Astruc: "I have found in this work a realization of my ideal in painting; the view of these masterpieces has given me great hope and full confidence." On Manet's return to Paris, this new rush of confidence resulted in a series of "beggar-philosopher" paintings based on Velázquez's philosophers; indeed, the strong similarity between *Menippus*

and *A Philosopher* suggests a homage to the Spanish master. In transporting Velázquez's philosophers into the 19th century in the guise of beggars, Manet, in his position as artist and

> social commentator, identifies with the outsider – perhaps a legacy of Couture's romantic concept of the artist as isolated genius.

NAPOLEON III Manet's "beggarphilosopher" series represents some of the victims of the rapidly changing Parisian society under Emperor Napoleon III. Conditions for urban "gleaners", such as rag pickers and beggars, had steadily worsened.

> THE RAG PICKER 1865; 195 x 130 cm (76¾ x 51¼ in) The rag picker was an outsider whose lifestyle was under threat in a "new" Paris that had no place for him. He came to represent pre-Haussmann Paris, and his image appeared in many popular publications. Manet's Absinthe Drinker (right and pp. 12–13) was based on a real-life rag picker, Collardet.

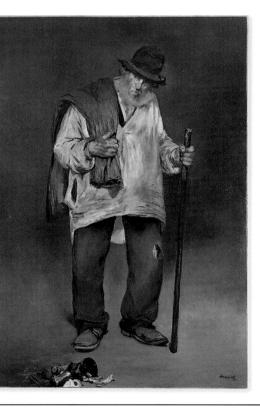

A NEW CITY Baron Haussmann's (p. 14) reordering of Paris included the extension of its 12 *arrondissements* to the 20 in existence today. The rapidly expanding city burst its boundaries, and forced those living on the outskirts into a zone that was neither city nor suburb: the *banlieue*.

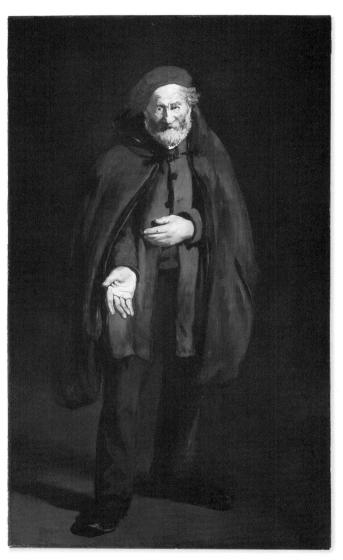

The Beggar (The Philosopher)

1865; 118.5 x 109 cm (46% x 43 in)
Manet's philosopher actively plies his trade as a beggar.
His outstretched hand, however, suggests an offering as much as a supplication, as though bestowing
wisdom on us, the impoverished. His mock-humorous expression, as often assumed by beggars in their interactions with the public, is also weary and thoughtful. There is a strong colour affinity between this painting and Delacroix's *Barque of Dante* (pp. 8–9), and it is tempting to interpret Manet's beggar-philosopher as a distant relative of the great poet-philosopher, Virgil.

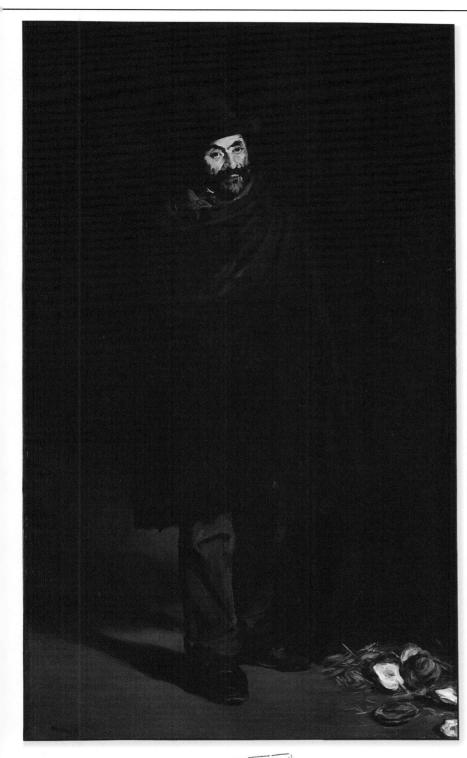

A Philosopher

1865; 187.3 x 108 cm (73³/₄ x 42¹/₂ in) Manet exhibited this painting at his first oneman show at the Exposition Universelle in 1867. His work had just been rejected from the Salon of that year, so instead of attempting to exhibit at the official art pavilion, he followed Courbet's example and erected his own pavilion nearby. Characters such as this one (left) were an unwanted presence around the fabulous Exposition Universelle - Napoleon's model of society. Manet's Philosopher, then, was an apt addition to this exhibition by a rebel.

SOMBRE COLOURS There is a remarkably limited colour range used in A Philosopher, consisting largely of blue-grey, green-grey, and brown. Yet the painting is not dull.

DEFT TOUCHES Manet's treatment of space is reminiscent of his Tragic Actor (p. 36) and The Fifer (pp. 40-41). The light, feathery brushwork, however, particularly to the right of the philospher's legs, is even more loosely suggestive and abstract.

USE OF LIGHT The philosopher, wrapped in a blanket to protect him from the cold night air, stands in the wan light, cast possibly by a street lamp.

PREVIOUS STUDY

Manet had painted several still lifes with oysters in the previous year. He may have used one of these works as reference for this painting.

MENIPPUS

Velázquez; 1639–40; 179 x 94 cm (70½ x 37 in) Velázquez's "pairing" of the ancient Greek philosophers, Aesop and Menippus (the satirist), was the first time the two were linked as dual exponents of common wisdom. Whether Manet was aware of this or not, he had an exact, intuitive understanding of painting. Instead of the attributes of learned thought arranged at Menippus' feet (right), Manet's philosopher (above, left) stands near a pile of straw and discarded oyster shells. His knowing expression seems to invite comparison of these sad attributes to those of his eminent ancestor.

SHADY CARICATURE

Philosopher (above) in his caricature for Le Journal

Amusant, 1867. He also

caricatured Manet's one-

man exhibition pavilion

(top right), which he labelled "The Temple

> of Good Taste" and "Musée Drolatique"

Randon has picked up on the somewhat

cloak-and-dagger

appearance of A

39

THE ABSINTHE DRINKER 1859–67; 181 x 106 cm (71¹/₄ x 41³/₄ in) Around 1867, Manet extended The Absinthe Drinker and added it to the other "beggar-philosopher" paintings, to complete the series. How far Manet had progressed can be seen in its cruder handling.

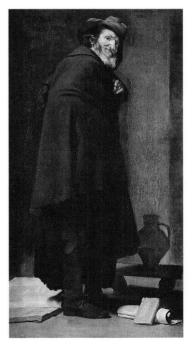

A misjudged masterpiece

EMILE ZOLA SAID OF *The Fifer*: "I do not believe it possible to obtain a more powerful effect with less complicated means." Manet had learned from Velázquez (p. 38) the power and eloquence of the solitary figure in undefined space. In *The Fifer*, he combined this knowledge with strong references to Japanese prints. The firm "outline" and bold

The Fifer

1866; 160 x 98 cm (63 x 38½ in)

Manet had already been criticized for his "flatness" and lack of obvious modelling, and when he submitted *The Fifer* along with *The Tragic Actor* (p. 36) to the Salon of 1866, both were rejected. This time it was not a question of "morals" but of talent: the jury considered both paintings inept. In rejecting *The Fifer* they revealed their blindness to the modern developments in painting, and to the sophistication of Manet's art.

division of flat areas of colour in *The Fifer* echo the sharply delineated *Ukiyo-e* ("floating world") and brightly coloured *Nishiki-e* woodblock prints then in circulation, by artists such as Utamaro and Kuniaki II (p. 41). These prints relied upon the drawing and skill of the artist to maintain the delicate balance between abstract and "real" space. Manet was blessed with such skill and knew instinctively the value of economy of line and brushwork.

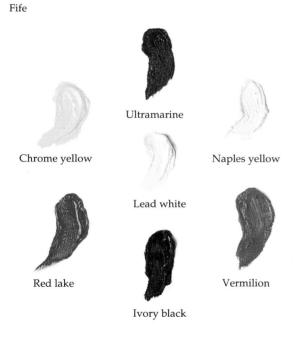

MATERIALS

The powerful effect of *The Fifer* is in large part due to an inspired use of just a few strong colours. The cool, neutral space from which the fifer emerges, reinforces, by its vagueness, the solid impact of the figure, which appears in sharp focus against the unspecified "infinity" of the background. The rich black and red blocks of colour in the fifer's tunic and trousers are weighted down by the areas of sharp white.

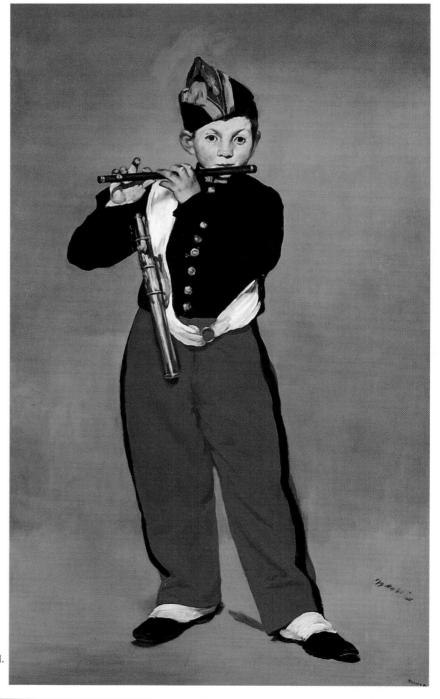

TRUE DEFINITION

The strange shape of the fifer's hand, with dark, distorting shadow, painted without concession to artificial refinement, would have seemed simply bad painting to the jury who rejected it. The critic Paul Mantz called *The Fifer*: "An amusing specimen of primitive illustration."

FLAT COLOUR

With very few shadows and almost no modelling, the fifer's baggy trousers would indeed appear flat and empty, were it not for the black strips on each leg – skillfully applied to suggest form and volume.

- Flat plane of red outlined in black is reminiscent of Japanese woodblock prints

Grey background evokes the smoke of a battleground

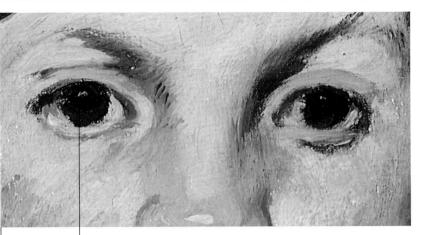

The slightly unfocused eyes convey the remoteness of a child's gaze

EYES OF YOUTH

Berthe Morisot (pp. 46–47) wrote: "Only Manet and the Japanese are capable of indicating a mouth, eyes, a nose in a single stroke, but so concisely that the rest of the face takes on modelling." Moreover, Manet has captured the guileless, child-like expression of the boy.

DOUBLE SIGNATURE

Manet signed *The Fifer* twice: in the bottom right-hand corner, and again much larger, as an integral compositional device. Running parallel to the diagonal created by the fifer's foot, it helps reinforce the impression of solid ground.

BLACK AND WHITE

This very pleasing bit of painting is as much a signature for Manet's style as is his name. The spat is sculpted out of thick, unmixed white paint, applied back and forth, describing the form beneath. *The Fifer* has undoubtedly darkened with age and, like *Olympia* (pp. 28–29), lost some

of its original raw impact. It is nevertheless still startling in its freshness of colour and handling. Manet loved black and, unlike the Impressionists, valued it highly as a colour. Recent analysis has shown that he mixed pigments such as cobalt blue, yellow earth, and chrome orange with ivory black, to create tones in the black.

> Sculpted application of white paint gives solid form to the spat

Shadow "anchors" the image in indefinite space and helps to define the floor plane

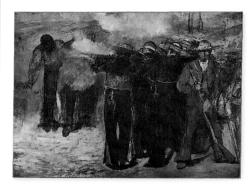

THE EXECUTION OF EMPEROR MAXIMILIAN 1867; 196 x 259.8 cm (77¼ x 102¼ in) Manet's first version is closest of all to Goya's impassioned drama (below) and is more fiery and unrestrained than subsequent portrayals.

The Maximilian affair

MANET'S CONTEMPT FOR history painting did not mean that he avoided contemporary political issues. He was deeply affected by an extraordinary series of events in Mexico: the Maximilian affair. In 1860, the revolutionary, Benito Juárez, overthrew General Miguel Miramón to become President of Mexico. He refused to acknowledge Mexico's debts to France, Spain, and Britain, and in 1861 the three nations invaded Mexico. Spain and Britain soon withdrew but Napoleon III had other

plans: in 1863, French troops took Mexico City and installed the Austrian Archduke Maximilian as Emperor. Maintaining French rule in Mexico, however, was a difficult, costly operation, involving 40,000 French soldiers. In 1867, Napoleon withdrew all his troops, abandoning Maximilian to his inevitable fate: within three months, Maximilian was captured by Juárez's guerillas, and executed.

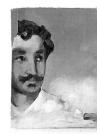

Reconstructed fragments of original painting

THE THIRD OF MAY, 1808 *Francisco Goya;* 1814; 268 x 347 cm (105½ x 136½ in) Manet's paintings of the *Execution of Maximilian* were largely inspired by Goya's *Third of May,* depicting atrocities committed by the French army in Spain in 1808.

THE EXECUTION OF EMPEROR MAXIMILIAN 1868–69; 252 x 302 cm (99% x 119 in) Full details of the events in Mexico did not reach Paris all at once. The first version Manet painted of the incident (top), depicting the firing squad in traditional Mexican uniform, accords with the public's initial horror at Juárez's actions, and the blame lies firmly with the Mexicans. This (right) is Manet's largest version and the last of the four that he painted in the series.

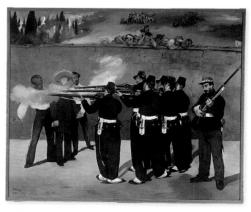

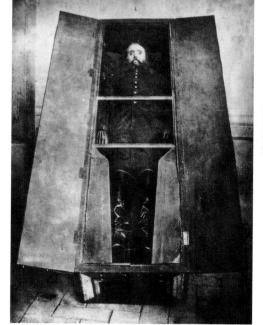

RELICS OF A VIOLENT DEATH After the execution of Archduke Maximilian, his remains were displayed in an open coffin (above). His eyes were replaced with black marble, and vital organs preserved in compartments by his legs. The shirt worn by Maximilian at his execution (right) was photographed, showing where the bullets entered his body. Fiercely loyal to his adopted country, he died declaring, "May my blood flow for the good of this land. Viva Mexico!"

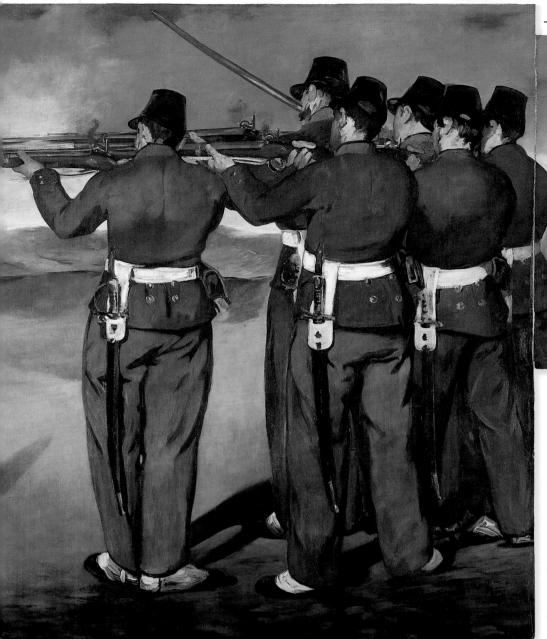

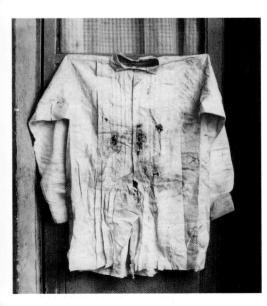

The Execution of Emperor Maximilian

1867-68; 193 x 284 cm (76 x 111¼ in) In this version the action takes place in broad daylight, in the open country, with the firing squad at point blank range. This work of cold brutality has a power to shock akin to photo journalism. It has an almost amoral quality, making it one of the most disturbing images of its kind. Through his controlled detachment, and by placing the firing squad in French, not Mexican, uniform, Manet subtly condemns Napoleon's own indifference to the fate of

Maximilian. A truly political work, it was never exhibited in Manet's lifetime and his later lithograph of the painting was confiscated by the government.

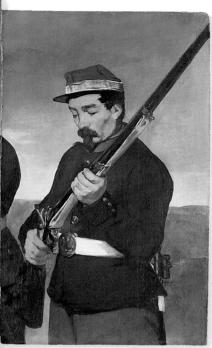

A FRAGMENTED PAINTING

There is a remarkable story behind the present condition of this painting. After Manet's death, Léon Leenhoff, hoping to make it more saleable, cut out the soldier (above). It was bought by Degas (p. 27 & p. 33), who was told that the rest of the painting was destroyed by accident. When other fragments turned up at Degas' own picture restorer, he was furious, saying, "You're going to sell me that. And you'll go back to Mme. Manet and tell her I want the legs of the sergeant that are missing from my bit, as well as what's missing from yours". One can imagine his reaction on discovering that Léon had used them to light a fire.

THE END OF A LEGEND Napoleon's ruthless action was a disgrace and marked the beginning of the end for the Second Empire, which finally collapsed during the Franco-Prussian War (1870–71; pp. 46–47).

"UNE PETROLEUSE" This powerful image of one of the notorious petrol-bombers reflects the active role taken by women during the conflicts of the Paris Commune.

The fall of Paris

IN JULY 1870, FRANCE DECLARED WAR on Prussia. Only two months later, Napoleon III surrendered his troops at Sedan, north-east France. When news reached Paris, angry mobs forced the collapse of the ailing Empire, and the Third French Republic was proclaimed. The war resumed and in two weeks Paris was under siege from the Prussian army. Manet had joined the National Guard and sent his family to the country. Four months later Paris had capitulated, and Manet was free to re-join his family. When he returned to Paris in May 1871, it was in the depths of civil war. The radical Republicans

and socialists had refused to accept the government's terms of surrender, and had elected a municipal council: the Commune. The wars affected Manet profoundly, and he later suffered bouts of depression.

Jene, 16 762 monther David Je 30 mornie las tallians pour allique Denne mettres Damp le Seege . en vais. dade Valence aborn

LETTER TO DURET

During the siege Manet had closed his studio at the rue Guyot, and entrusted his friend Théodore Duret with the safe keeping of its contents. In a letter to Duret in which he lists the paintings to be stored by his friend, Manet adds a touching foot-note: "In case I should die, I would like you to keep <u>your</u> choice of *Moonlight* or *The Reader*, or if you prefer, you can ask for the *Boy with the Soap Bubbles* [p. 34]."

A SPONTANEOUS IMAGE

According to Duret, the drawing for this lithograph, entitled *Civil War* (1871–73), was done on the spot, at a scene of carnage Manet happened upon "at the corner of the rue de l'Arcade and the Boulevard Malsherbes". Whether or not this is true, it remains an enduringly tragic image, and is markedly similar to Manet's *Dead Toreador* of 1863 (p. 19). Manet joined the war as an artillery man, but was soon made a lieutenant. He was never involved in combat, and found life as a soldier "boring and sad". In a letter to Suzanne, written four months into the siege when he was cold, miserable, and suffering from flu, he described "doing your portrait from a photograph on a little piece of ivory. I long to see you again, my poor Suzanne, and don't know what to do without you".

DEAD COMMUNARDS

These corpses, lined up in makeshift coffins, were victims of the terrible fighting that took place in the streets of Paris between the Communards and the federal army. The Communards eventually succumbed – during what became known as "the Bloody Week" – to the larger force. By the end of the conflict, at least 20,000 Parisian citizens had been massacred by the 70,000 troops ordered in to the city to suppress the Commune.

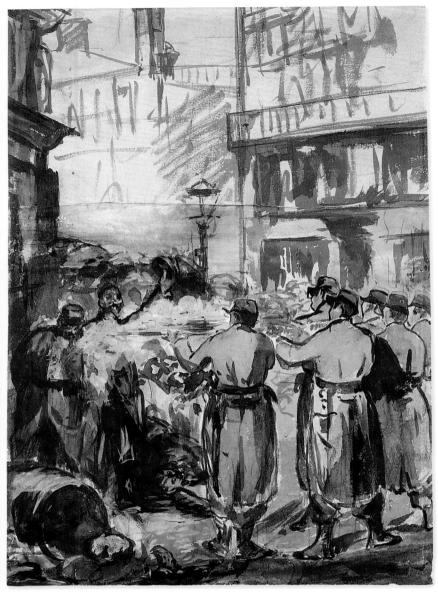

THE BARRICADE above 1871; 46.2 x 32.5 cm (18% x 12% in); pencil, ink wash, watercolour, and gouache Manet had planned a large painting, *The Barricade*, for the 1872 Salon, based on his *Execution of Maximilian* (p. 42 and below). This execution scene is a vertical re-working of the originally horizontal composition, and Manet added a piece of paper to extend the composition.

THE BARRICADE *left* The reverse side of Manet's *The Barricade* shows the original tracing he made of his 1868 lithograph *The Execution of Maximilian*. His next step was to turn the paper over and re-trace the image, which was then the starting point for *The Barricade*.

HARD TIMES

The siege was a time of great hardship for the inhabitants of Paris, with living conditions worsening daily, and people dying from starvation and disease. This satirical drawing, The queue for rat meat" depicts bourgeois citizens on their hands and knees, brought low by the need for food. When the siege was over, Manet wrote, "They are dying of hunger and even now there is great distress".

A SOLDIER'S WORDS Manet wrote frequently to his wife Suzanne from besieged Paris, and many letters were sent by hot-air balloon, the only "postal service" available. In the letter below, Manet expresses a soldier's weariness and cynicism about the cause of the Franco-Prussian war. He signs off: "Goodbye my dear Suzanne, I embrace you lovingly and would give Alsace and Lorraine to be with you."

Ballon monta Madanie D. Manet Ibig 21 2 dailhacar a Doron St Masia Barrss- 6 yrennee

Owient les more tane. non gain being papela in ash a tai g & burk hambred to for free & sats -. , nich parties, gais dra bion mariand in has ut ausuales der profite Der beson il mati-- awares 1; fline Harrent ille et aver de lier to charsett de mesant to as labour amition 1 theo the Dis ma a MS o - dailtracan for sm 200 27387

Paris 23 novambre This and again Juit , man in Queation son the ite Il tit mill tifeyour Cipions and participan seen i don Dance on Day and with or Varian war clarmant - formans normally sectionent - 129 House - Supplice interme 10. 2. + the + de duels gladin d'apre his - lean for Jage day der to it now fant to suist in nada ?

Manet and Morisot

LAS MANOLAS AU BALCON Goya; 1812; 194.8 x 125.7 cm (76% x 49% in) Manet saw this painting when he visited Spain in 1865, and would have seen it as an engraving in one of the many publications on Spanish art then circulating Paris.

IN THE PERIOD THAT FELL between the Maximilian affair (pp. 42–43) and Manet's involvement in the Paris Commune (pp. 44–45), he painted *The Balcony*. He had recently met the young painter Berthe Morisot, and *The Balcony* was the first of many paintings Manet made of her. Once again Manet makes reference to the Old Masters, this time paying tribute to another of the Spanish giants, Francisco de Goya. Manet has borrowed Goya's front-on compositional device; but where there is a mood of intimacy and intrigue between the characters on Goya's balcony, Manet has created a very Parisian, characteristically aloof, scenario. When Manet exhibited The Balcony at the Salon of 1869, it was met with considerable bewilderment. Moreover, the painting's bold colours, which seemed violent then – and still have a certain rawness

today – upset the critics.

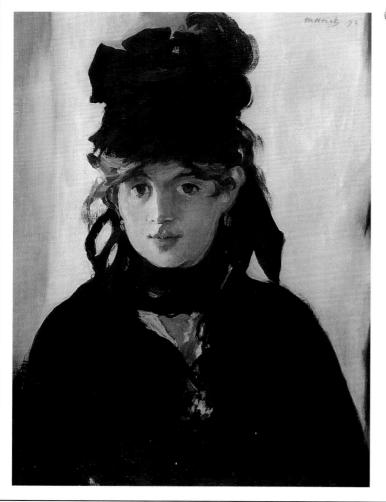

ACCOMPANYING MESSAGE The metal plate on Manet's gift to Morisot bears a direct transcription of his letter: "Don't be surprised at the arrival of a new type of easel which is very useful for pastels. It is my modest New Year's gift."

BERTHE MORISOT WITH A BUNCH OF VIOLETS 1872; 55 x 38 cm (21½ x 15 in)

This stunning portrait of Berthe Morisot is one of Manet's finest paintings and, perhaps in acknowledgement of this, he painted the little bunch of violets for her. They first met in the Louvre where she was copying a Rubens, and became life-long friends. There seems to have been some degree of mutual infatuation over the course of their relationship, but this was possibly no more than enthusiasm for each other's company. The Manet and Morisot households became permanently connected, however, when Berthe married Manet's younger brother, Eugène, in 1874.

WOMAN AND CHILD Berthe Morisot; specification unknown Morisot owed a certain debt to Manet in the development of her relaxed brushwork; she, in turn, having adopted the light, "synthesized" colour of 1870s' Impressionism, influenced Manet's palette. Her paintings of gardens may also have led him to tackle the same subject later.

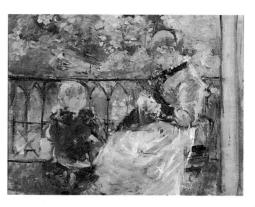

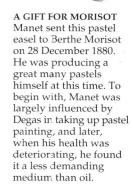

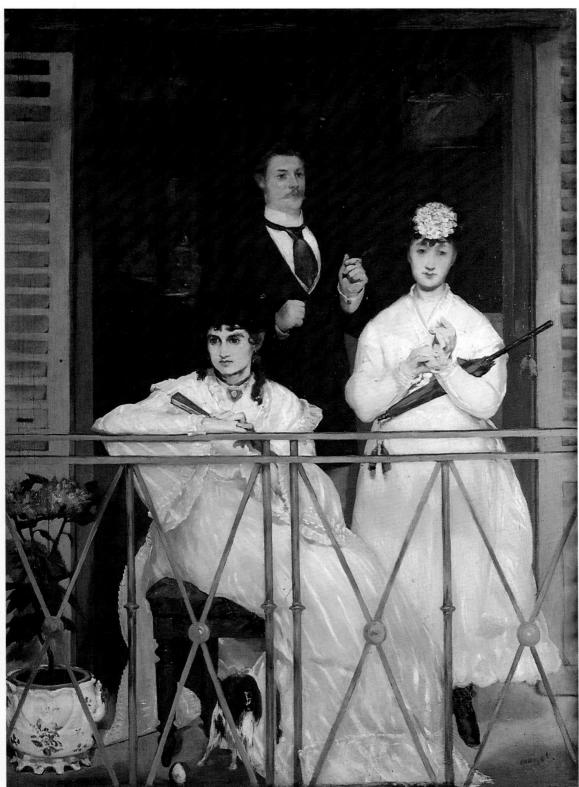

The Balcony

1868–69; 169 x 125 cm (66½ x 49¼ in)

Manet struggled with this painting and was nervous about the response it would get at the Salon. Morisot recalled that "He was laughing, then he had a worried look, assuring everyone that his picture was very bad, and adding in the same breath that it would be a great success". THE LEADING FEMALE IMPRESSIONIST Berthe Morisot had taken lessons early on from the ageing landscape painter Camille Corot, and she later became a leading member of the Impressionists. Naturally moody and sensitive, she struggled with depression, and she bitterly resented "the injustice of fate" that, in making her a woman, held her ransom to the conventions of the day.

CRITICAL CARTOON This caricature, by Cham, was accompanied by the warning, "Do close that window! What I'm telling you, M. Manet, is for your own good".

NOTE OF BLUE

Prominent amidst the intensely green-dominated colour harmonies, is the gentleman's silk cravat. Its beetle-wing, iridescent blue is utterly dissonant from the rest of the painting. It works as one of Manet's often quirky, isolated "notes" of colour.

WEARY MODELS All the models who posed for the lengthy, tiring sittings Manet required for *The Balcony* were friends of his: Antoine Guillemet, Fanny Claus, Berthe Morisot, and, in the background carrying a tea urn, Léon Leenhoff (p. 26).

SURFACE QUALITIES The heavily built-up paint surface of Morisot's portrait is proportionate to the intensity of her expression; conversely to that of Fanny Claus, whose vague, indeterminate expression is rendered almost as a sketch.

FROZEN ACTION Critics were at a loss as to *The Balcony*'s meaning. One woman puts on her gloves and is about to leave, the other is absorbed by something in the street, while the man stands as though under a spell.

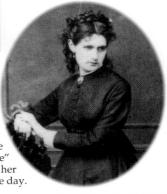

Detachment and intimacy

WE KNOW FROM DOCUMENTARY evidence that Manet was a popular socialite; there are many accounts of his charm, gaiety, and physical appeal from his friends and acquaintances. Stéphane Mallarmé called him "goat-footed, a virile innocence in beige overcoat; beard and thin blond hair, greying with wit". It seems his passion for the city and its nightlife, and his curiosity for every new spectacle the city had to offer, was tireless. Yet, for all this superficial gaiety, there runs through the whole of Manet's work a seam of doubt, and a form of emotional paralysis. It suggests that underneath his suave public exterior there existed a very different, private character that found expression in his paintings. The painter Ernest-Pierre Prins (widower of Fanny Claus, p. 47) wrote, after Manet's death, of his "underlying neurosis which he harboured, for all his outward insouciance". Contrary to his image of smiling confidence, Manet was assailed by self-doubt: "Abuses rain upon me like hail … obviously, somebody is in the wrong."

A VIEW OF MANET "The soul of generosity and kindness, he was apt to be ironical in speech, often cruel. He had a formidable wit, at once trenchant and crushing." Armand Silvestre.

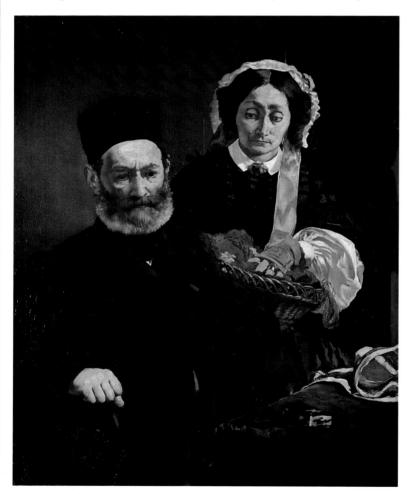

PORTRAIT OF M. AND MME. MANET 1860; 110 x 90 cm (43¼ x 35½ in) It is strange that the inability of Manet's characters to engage the viewer, or communicate with each other, should exist in paintings where he had chosen models from among his close family and friends (p. 47). It is tempting to look for clues to Manet's emotional development in this portrait of his mother and father, an early manifestation of anxiety and isolation.

IN THE CONSERVATORY $1879; 115 \times 150 \text{ cm} (45\% \times 59 \text{ in})$ In Manet's portrait of the fashionable young couple M. and Mme. Jules Guillemet, the American "beauty" and her husband seem artificial, icily remote from one another. With their newly-wed status, one would expect to see a warmer, more intimate mood.

AT THE CAFE-CONCERT 1878; 46 x 38 cm (18 x 15 in) At the Café-Concert is a sensitive portrayal of loneliness and isolation. In an atmosphere of noise, heat, and smoke, the main characters seem lost in themselves. They look in opposite directions, making no eye-contact. The caféconcert (pp. 56-57) attracted members of all classes, but the close proximity of the tophatted gentleman to the working girl, if anything, increases the sense of isolation.

PORTRAIT OF ANTONIN PROUST 1880; 129.5 x 95.9 cm (60 x 37³/₄ in) According to Proust, Manet intended to paint his portrait, "on unprepared white canvas, in a single sitting". And Manet did virtually complete it in one sitting: "After using up seven or eight canvases, the portrait came all at once." At the 1880 Salon, many critics complained that it was unfinished, but it also received enthusiastic reviews, even from Paul Mantz (p. 41): "The painter has given his model a great deal of swagger and a gallant air which is indeed that of Antonin Proust. The whole face is alive and the colour harmony dominated by a grey blue, is sober, distinguished, and elegant."

LETTER OF THANKS

In an article published in 1874, Mallarmé defended Manet and the artist sent him thanks: "If I had a few supporters like you, I wouldn't give a f... about the jury. Yours ever, Ed. Manet."

PORTRAIT OF STEPHANE MALLARME

1876; 27 x 36 cm (10³/₄ x 14¹/₄ in) Manet first met the poet Stéphane Mallarmé in 1873, when he was still an unknown English teacher, and they became very close friends. Manet illustrated Mallarmé's own works (p. 37) as well as his translations of Edgar Allan Poe's poems. This intimate portrait reveals something of their intense friendship. After Manet's death, his widow wrote to Mallarmé: "You really were his best friend, and he loved you dearly."

A LOYAL FRIEND The only source for some of Manet's earliest sayings is Antonin Proust's "Souvenirs de Manet", first published in 1897. Manet and Proust were schoolboys (pp. 6–7) and students (pp. 10-11) together and they remained life-long friends. Proust's "souvenirs" are unfailingly loyal (sometimes even biased or inaccurate) reminiscences of their friendship, which offer a very human account of the artist.

707 BROADWAY,

CONFIDENT CHARM In this odd "calling card" Manet makes a joke at his own expense, perhaps in the hope of endearing himself to the beautiful New York entertainer: "Enter! Enter! See the famous pictures of the famous painter Edouard Manet."

Antonin Proust

Costa d'anin Inilie 2

Message written on back of entertainer's card

chog ! Luting ? he heintre?

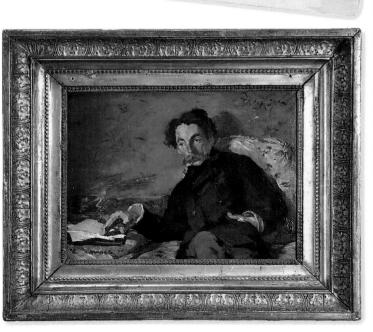

The respectable rebel

FRONT PAGE EXPOSURE This journal illustrates *Le Bon Bock*'s popularity, and includes Manet's unpopular work of the 1881 Salon and controversial Legion of Honour medal awarded to him that year (p. 58).

A CENSORED WORK Manet's lithograph, Polichinelle (right), was banned for its likeness to President MacMahon. WITH HIS PAINTING *Le Bon Bock*, Manet at last began to receive the recognition he had craved from the Salons for 12 years. It was his first real success with the critics since the honourable mention he received for *The Spanish Singer* (pp. 18–19) at the Salon of 1861, and it was popular with the public. Manet had already achieved considerable fame, but this new attention signified that the establishment he had battled against for so long had finally come to accept him

as an important figure. Conversely, members of his own artistic circle, and the young radicals who regarded Manet as the leader in their attack on the establishment, saw *Le Bon Bock* as something of a compromise, and Albert Wolff, the notorious critic for *Le Figaro*, accused Manet of "watering his beer". It is ironic, then, that in 1874, the same year as the first Impressionist exhibition, which provoked much scandal, Manet produced *Polichinelle*, an image that the government immediately banned.

> Polichinelle poem

Loin to bands, find affante " Lain to bands, find affante " La vigne De to diano out the Jui Schwar phe Vann out the Dans to app and all of the Mante dans and sail of the Je out dails latter and and f Gui par da water and and f Gui par da water and and f

Je duis to Riching the

Reptichen Guerals & Solans -Moi, Schittman auer Angette Les formule de montal gette Juagues au Son Hund othe getenmontal & Schothan getenmontal for Schothan -Je des Schothan for forder an all for the Schothan Blochington !

Dogun and Helgen Vernanded Solgan and Helgen Vernanded Solgan and Constant of Sol Solgan and Son Solar Solar Solar Solar Solar Cost in source of Solar Solar Solar Solar (Solar Solar Solar Solar Solar Solar Solar Solar (Solar Solar Solar Solar Solar Solar Solar Solar (Solar Solar Solar Solar Solar Solar Solar Solar Solar (Solar Solar Solar Solar Solar Solar Solar Solar Solar (Solar Solar Sol

Chint poine di one bend onote Tento aie anime) hai ha onatomete ; Centra pa, yac l'espissione onangae, Prins ha effente bellin barrique ; Ma Maccine dan fai ai lei, Bat ha caise en fai ai lei, gardee par lane continello.

I The finis Folichimile

THE TOPER Frans Hals; 1628–30; 81 x 66.5 cm (32 x 26% in) Manet visited Holland again in 1872. He studied the work of the painter Frans Hals, whose *The Toper* was the inspiration for *Le Bon Bock*. Manet has preserved the same spirit of smiling joviality in *Le Bon Bock*, a portrait of the engraver, Emile Bellot.

COMPLEMENTARY VERSE Manet set his friends the task of composing a verse (above) to accompany *Polichinelle* (who was known throughout Europe

as a grotesque figure of comedy).

mouner

CONSERVATIVE PRESIDENT In 1874, Marshall Marie Edmé MacMahon was elected President of the conservative Republican France. Manet was himself a committed radical Republican and strongly opposed this government; furthermore, he had been witness to MacMahon's terrible crushing of the Commune in 1871 (pp. 44-45).

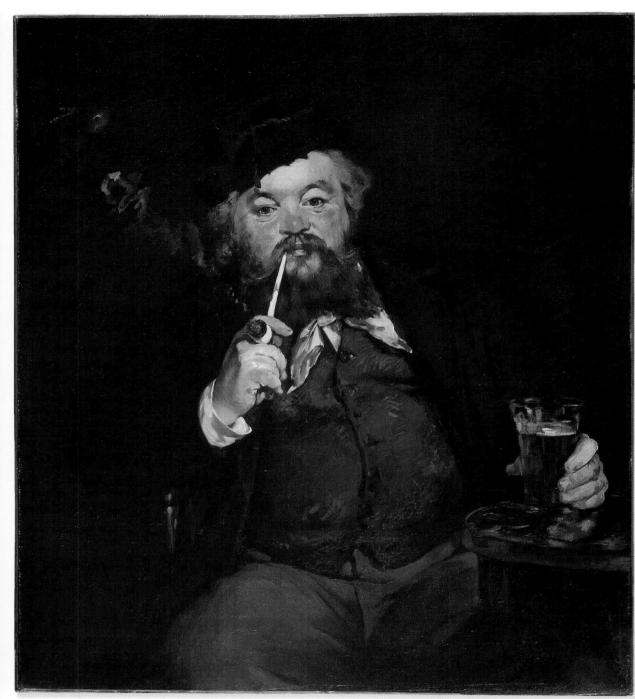

THE SPIRIT OF HALS The ruddy, applelike complexion of the engraver Bellot is very much in the spirit of Frans Hals' rosyfaced wenches and carousers, and it is painted with a bravura to match.

CARICATURE Second to Olympia, Le Bon Bock was the subject of more caricatures than any other Manet painting. This time, however, after initially ridiculing the painting, the cartoons began to express its popularity.

MASTER'S IMPACT Although this painting makes reference to Hals, its warm, grey tonality and subtle range of browns, also summon up the paintings of Velázquez – Manet's most enduring influence.

THE CRITICS "What a hard, flat, confused, uncertain touch!" Criticisms like this one from Ernest Duvergier de Hauranne in 1873 are hard to understand when confronted with the actual painting.

Le Bon Bock

1873; 94 x 83 cm (374 x 324 in) Because *Le Bon Bock* was directly reminiscent of Dutch art (unlike Manet's previous irreverent references to some Old Masters), he received praise from the most conservative of critics. The annual Salon review, "*Revue des Deux Mondes*", which had completely ignored Manet throughout his career (maintaining a haughty silence even through the uproarious years 1863 and 1865), now awarded him lengthy, serious critical attention.

ACCOMPANYING POEM

Carjat wrote a poem to accompany Manet's *Le Bon Bock*. This character has witnessed all the horrors of the Paris Commune, yet Carjat concedes that life goes on – with pleasures such as food and, above all, a good beer.

Clay pipe

the min hant to book gut profile an agree tabae at him his common hier rite profile an agree. I have ha and another rite a la tratade, an ad him der reliet tout affair a function

article homene 1 it a ver la tertitie of a singe the art of the sea to the set to neighface value mattering to the set to neighface value mattering in the proof a part. The sea of the second second second second to the face second second second second of the second second second second second of the second second second second second the second se

D LE BON BOCK LOWER IN

Manet or Monet?

"WHO IS THIS MONET WHOSE name sounds just like mine and who is taking advantage of my notoriety?" This was Manet's initial reaction to the hitherto unknown Monet, recorded by Théodore Duret in 1865. He was irritated by the attention the young painter was receiving and exasperated by the ensuing confusion over their names. Manet was already regarded as a modern master by the young *avant-garde*, and as their leader in the attack on stale academic values. Manet and Monet

MANET'S OUTLOOK The first Impressionist exhibition took place in 1874 at the studio of the photographer Félix Nadar (left) in Paris. Manet was invited, but declined to take part in the exhibition. Reluctant to be seen as part of any group, and perhaps not wishing to tarnish his success at the previous year's Salon (pp. 50-51) by publicly associating with the young "unknowns", he continued to submit work to the Salon.

were to become good friends (pp. 54–55), and although they admired each other's work, their artistic ideals and aspirations were very different. Though Manet's palette lightened in succeeding years, and he adopted a more naturalistic approach under the influence of Impressionism, he remained essentially a studio painter.

Claude Monet; 1873; 48 x 63 cm (19 x 24% in) At the Salon of 1866, when Manet's paintings had been rejected and Monet's accepted, the critic Félix Jahyer was spiteful enough to write: "Since Manet has been politely shown to the door, Monet has been chosen as leader of this brilliant school." It wasn't until eight years later, at the first group exhibition organized by Monet, that this brilliant new school was first named by the journalist and critic Louis Leroy – The Impressionists, after Monet's much maligned painting (right).

MONET IN HIS STUDIO BOAT 1874; 80 x 98 cm (31½ x 35½ in) Manet shows us Monet in deep concentration, at work on one of over 150 landscapes he painted in his six years at Argenteuil. Monet constructed his floating studio in imitation of one of French Impressionism's predecessors, Charles-François Daubigny.

> CLAUDE MONET This wonderfully concise brush and ink portrait of Monet was done during the summer Manet spent painting in Argenteuil with Monet (pp. 54–55). Monet is wearing his painting hat, as in his portrait (left), but there the brim is turned down to shade his eyes.

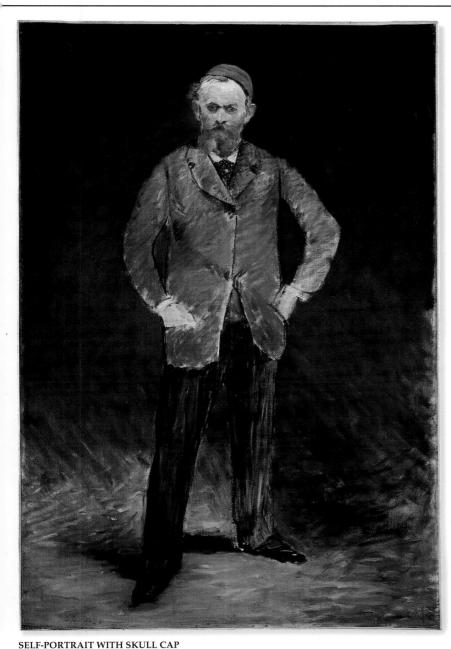

14 May

mon thes Wall. manami's Mis monet Sistey Romain me Beste mansor rant faire une exparition of me rente salle Dimon, m De la m's Dait tulale Asie de Veren in Delos m's van more have de Verein reur darter un cately runz mon dards aits raw darter in a de Teame dardsan et un invitation, & de Teame s'ert gail it un i wind atticket hierthan contrarie mademante un det. Cartle mon d'a un dalan raus n'as may than even a lisentat dan ratte perntase la pen

LETTER TO WOLFF Although Manet never associated himself with the Impressionists, this letter to the critic

Albert Wolff shows support for his "friends, Messrs. Monet, Sisley, Renoir, and Mme. Morisot. Perhaps you do not yet like this kind of painting, but you will. In the meantime, it would be very kind of you to mention it in Le Figaro".

ARTIST OR CHRIST? The cartoonists seized on the reverential tone of Fantin-Latour's portrait (below): Bertall's cartoon is a parody of Christ teaching his apostles.

mais raus

an attende

Server bien armalle Den Harles im Asic

Dans le disaro.

Si Je se Your ai has

for manet

1878; 94 x 64 cm (37 x 25¼ in) This self-portrait was painted the same year Manet's incurable illness was first diagnosed. The defiant pride with which he confronts the viewer is belied by the anxious expression in his eyes, as he turns

in on himself, momentarily lost in thought, and by the signs of illness visible in his face and stiff pose.

A STUDIO IN THE BATIGNOLLES

Henri Fantin-Latour; 1870; 204 x 273.5 cm (80¹/₄ x 107³/₄ in) In his group portrait of Manet at work in his studio, surrounded by admiring onlookers that include Zola, Monet, and Astruc, Fantin-Latour acknowledges Manet's position as leader of the avant-garde. Renoir (third from the left), said of him: "Manet was as important to us as Cimabue and Giotto were to the Italian Renaissance."

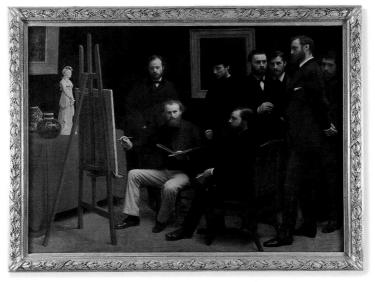

KING OF THE IMPRESSIONISTS As champion of the avant-garde, Manet was seen as representative of the new or radical forms of painting, and the term "Impressionist" was applied as a label for many diverse styles deviating from the norm. Despite such confusion, Manet stands alone and cannot be regarded as an Impressionist.

An Impressionist landscape

Manet Spent the summer of 1874 at his family home in Gennevilliers, and painted alongside Claude Monet (pp. 52–53) who lived on the opposite bank of the Seine at Argenteuil. He especially admired the work of the younger painter, whose influence we can see in this landscape – Manet's most

Portable paint box

Impressionistic work. At the beginning of the 1870s Manet had begun to paint more outdoors, and these paintings marked the start of a less "contrived", more naturalistic depiction of modern life. However, besides a small body of paintings that were loosely Impressionist in their execution and subject matter, the Impressionists' influence on Manet is most marked in the consequent lightening of his palette.

The Seine at Argenteuil

1874; 62 x 103 cm (24¹/₂ x 40¹/₂ in)

In this quiet painting of Monet's first wife, Camille, and their son Jean, Manet has subordinated the figures in favour of the whole. It has an uncharacteristic incidental quality, and the figures seem unaware of the spectator. This is relatively rare in Manet's work, where psychological tension of some form is often present and figures possess an undeniable self-consciousness.

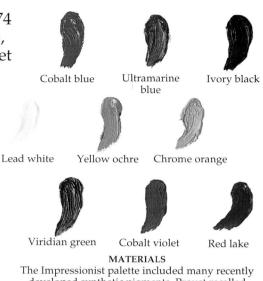

developed synthetic pigments. Proust recalled Manet saying; "I have finally discovered the true colour of the atmosphere. It's violet ... Three years from now everyone will work in violet." Cobalt violet first appeared in 1859, and was included in Monet's palette as early as 1869. But the pure, mauve pigment was not widely used until the 1870s; Manet has used it extensively here, especially in his painting of the water. Cobalt blue, sometimes known as Dresden blue, had been invented by French chemist L.J. Thénard in 1802.

ATTENTION TO DETAIL

Even in his most Impressionist painting, Manet did not abandon his beloved black. Although the figures are subordinate to the landscape, there is still a focal point in the black ribbons of Camille's bonnet. We can see Manet's unceasing curiosity about the accessories of modern living in his careful attention to the rather bizarre structure of the bonnet, similar to his wife's (p. 27).

Dense, rich colour applied in broad strokes

THE BOAT

This detail is another example of Manet's reluctance to adopt a genuinely Impressionist technique. Unlike the short and regular-sized brushwork that characterizes much of Monet's painting, he has painted the area central to the composition in long modulated strokes and unbroken colour. This tendency of Manet's to select from the scene and emphasize certain elements contradicts the Impressionists' almost egalitarian approach to the landscape – where one element is rendered with as much or as little importance as the next.

> The rapid, zigzag brushstrokes applied in layers, from dark to light, suggest depth and movement

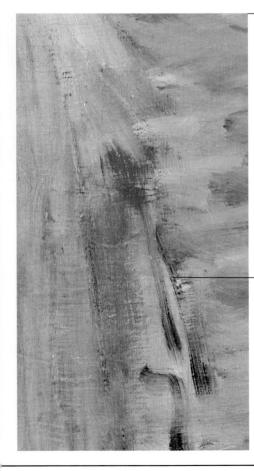

Paint is lightly dragged across the surface

SUGGESTED FORM

Camille's hand is barely suggested in a single broad brushmark of warm red. The paint is dragged over the surface, allowing cooler colours beneath to show through – neutralizing the red in this cool, blue-dominated picture. The stick, or umbrella, on which she leans, consists of three swift, softly applied strokes of black that disappear into the grass. Her dress is entirely composed of single brushstrokes reflecting either the dark green of the grass and cool blues of the water in the lower half, or the warm light falling on the upper half.

IMITATING WATER

Manet surely looked to Monet for example in his painting of water, acknowledging Monet's "understanding of its mystery and all its moods", and calling him the "Raphael of water". In this detail, we can see how, with fast, zigzag brushstrokes, Manet has imitated the action of rippling water, employing complementary colours of cobalt blue and violet for the water, against chrome orange for the reflection on the boat's rigging. His use of complementary colours, however, is not schematic, nor consistent with the general Impressionist colour theory.

"UNE LOGE DU COCOTTES" This popular illustration of two fashionable prostitutes – very décolleté – seated in a box at the theatre, shows the kind of lifestyle available to the successful courtesan.

STAGE-PLAY OF NANA The enormous popularity of Zola's novel led to the staging of a theatre production at the Théâtre de L'Ambigu in 1881. Elaborate sets helped to make the play a success.

THE POPULARITY OF NANA Emile Zola's "Nana" provoked a storm of protest and excited gossip, and when the novel went on sale in 1880, it completely sold out: 55,000 copies were purchased in the first day. This poem by Alfred Barbou (right) is a celebration of *Nana*'s spirit.

Reign of the courtesan

HAUSSMANN'S MODERNIZATION of Paris (pp. 14 & 38) had altered the structure of the Parisian way of life. The boulevards had now become venues for daily entertainment for the pleasure-seeking bourgeoisie. With "strolling" now a popular activity, and families frequenting the cafés in search of the "vulgar spectacle" of the café-concert, the writer Maxime du Camp wrote: "One does not know nowadays ... if it's honest women who are dressed like whores or whores who are dressed like honest women." Increasing prostitution had become more visible since the great changes, and was a popular subject for artists and writers. Manet had sealed his notoriety with his earlier portrayal of a prostitute (pp. 28–29) and returned to the theme several times. With *Nana*, a witty image of prostitution, Manet was brazenly challenging the public and critics

by portraying this particular scene on such a daring and irreverent scale.

C'est alle a but Irana. Manot I après Zola, l'in painte. Dell'our maine l'impares se magaille Il de rouge et de blanc, sons le noir son ail lerible, ctil bele, que famais la purteux nes voi la .

Philes que nue con chaine alle de la la fi elle, De apare et ser chaixe qui tonde . Re mi tor. Alle no mis gone constit de sation et a babi elle. Colores , par Dien idennices, par la sois dem la .

Certe class t cent fois infame cette que ; On sait ce qui l'attend : aufourd hui le houtoir avec des colliers d'ore, et Demain le mattair.

22 Bien, malgre ta konte, o formelle de rue, Mana, tu n'allien pro le degre de metrije qu'inspira le colonieur de tes formes optis-

Steps Barbon Paris 8 allai 1877.

37194

INITIAL MANUSCRIPT "Nana" (left) was one of 20 novels in which Zola plotted the lives of one family. Although the title of Manet's Nana (right) is derived from Zola, the painting was completed before the book's release. Manet's Nana corresponds with her description in Zola's preceding novel, "L'Assommoir".

JAPANESE PRINT The stylized form of this print of a courtesan by Soken Yamaguchi is oddly paralleled by Manet's curvaceous Nana (below).

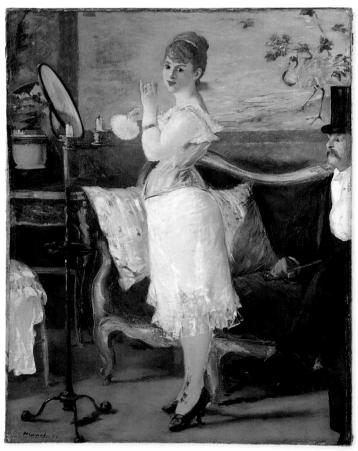

NANA

1877; 154 x 115 cm (60% x 45% in) Manet's return to the theme of prostitution (pp. 28–29) was a departure from his previous reliance on the Old Masters. Here is a contemporary scenario of a half-dressed courtesan who, presenting a smiling face to the viewer, seems very much in control of the situation. Her "protector", however, sits rigidly at the edge of the canvas, powerless to act. *Nana* was rejected as immoral, from the 1877 Salon.

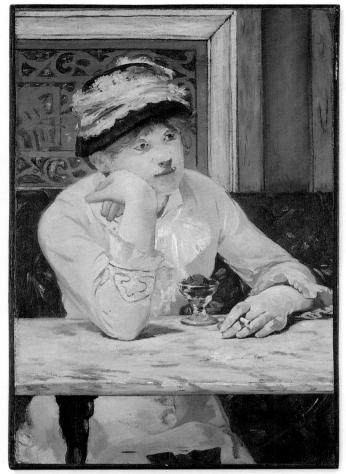

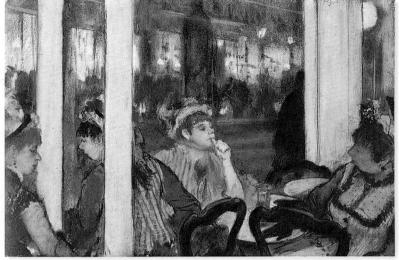

Plum glass

AT THE CAFE right 1878; 77 x 83 cm (30¹/₄ x 32³/₄ in) CORNER OF A CAFE-CONCERT far right; 1879; 98 x 79 cm (38½ x 31 in) These two café scenes started life as one canvas, a painting which Manet began in 1878 and originally titled Café-Concert de Reichshoffen. However, Manet cut the canvas into two pieces before finishing it (pp. 19 & 26). The left section became At the Café and the right section, which Manet extended with a 19-cm (7½-in) strip of canvas, became Corner of a Café-Concert. When the two sections are brought together, we are able to see how the two now very different paintings correspond to the original design.

THE PLUM

1878; 74 x 49 cm (29 x 19¼ in) In this portrait of boredom Manet shows another, less frivolous, world of the prostitute. As a woman alone in a café at night, her role is ambiguous: she may be one of the many "hidden" prostitutes, poor girls forced to supplement their mean existence. Her posture and distracted gaze sum up her lonely position, and the uneaten plum and unlit cigarette are indications of her poverty.

Originally one painting joined here

WOMEN ON A CAFE TERRACE *Edgar Degas; 1877; 41 x 60 cm*

Lagar Degas; 1877; 41 x 60 cm (16¼ x 23¼ in); pastel on monotype Many of Degas' intimate pastels of prostitutes tended to portray the poorer, uglier side of prostitution. This pastel of women plying their trade is closer to expressing the grim reality of their harsh existence than Manet's humorous Nana (far left), or his gentle, subtle work, The Plum.

ON THE BOULEVARD

In 1860, the Goncourt brothers, commentators on contemporary Parisian life, wrote, "Our Paris, the Paris where we were born, is passing away. Its passing is not material but moral. Social life is going through a great evolution which is beginning. I see women, children, households, families in this café. The interior is passing away".

The final masterpiece

THE JURY FOR THE 1881 Salon included several of Manet's friends. Of 33 jurors present at the honours selection meeting, 17 voted in favour of Manet, and he received a second class medal. By a majority of only one vote Manet, at the age of 49, had achieved his life-long ambition. Although he was now guaranteed acceptance to the yearly Salon, the grudgingly awarded honour came almost too late, and he died just two years later. It is fitting that Manet's final masterpiece should be a scene from modern Parisian life. *A Bar at the Folies-Bergère* was his last Salon work, painted when he was seriously ill in 1882. It was also his last large-scale canvas, the conclusive

painting to a series of smaller works on café life (pp. 56–57), and Manet returned to the Baudelairian idea of "the Heroism of Modern Life" (pp. 12–13 & 16–17).

WOMEN DRINKING BEER

1878–79; 61 x 60 cm (24 x 23% in); pastel on canvas Manet's pastel depicts two of the more "liberated" women that were now to be encountered in the cafés of Paris. Beer was one of the great many alcoholic drinks on offer in the ever-growing number of cafés: 24,000 by the end of the century.

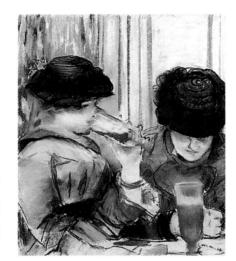

ROSES IN A

CHAMPAGNE GLASS 1882; 31 x 24 cm (12¼ x 9½ in) This painting evolved from the still life of roses in a glass in *A Bar at the Folies-Bergère*, Manet's last major work. His worsening condition meant that he could work only in short bursts at a time and on a smaller scale.

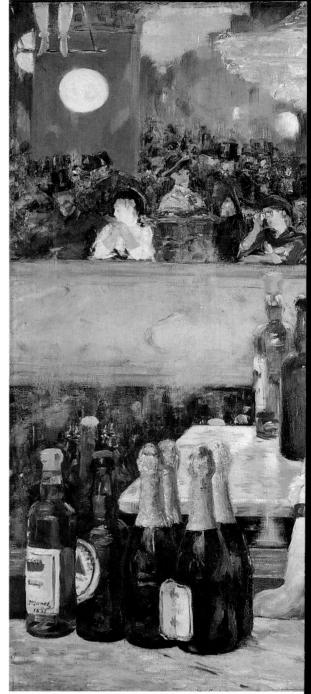

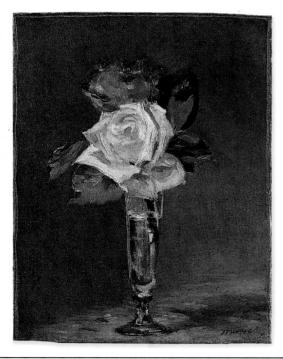

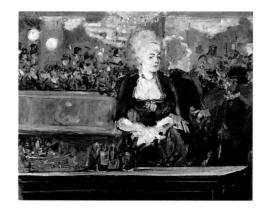

A BAR AT THE FOLIES-BERGERE (STUDY) 1881-82; 47 x 56 cm (181/2 x 22 in) The preliminary study for A Bar at the Folies-Bergère was painted "in situ" and shows a more relaxed, nonchalant barmaid. In the final version (right), using a different design (and different model), Manet opted for a strong personal presence, moving the figure right up to the picture plane in direct confrontation with the viewer. As a result, the viewer takes on the role of her customer, depicted only in reflection. Unusually, Manet did not use a professional model, but hired the young barmaid, Suzon, from the Folies-Bergère, to pose in his studio where he had set up a mock bar.

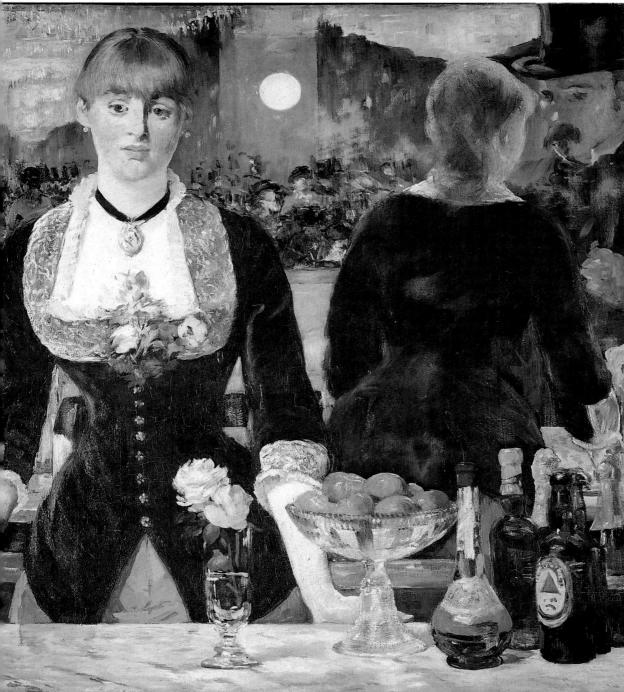

A Bar at the Folies-Bergère

1882; 96 x 130 cm (37³/₄ x 51¹/₄ in)

A young painter, visiting Manet's studio, described him at work on his last masterpiece: "Manet, though painting from life, was in no way copying nature; I noticed his masterly simplifications; the woman's head was being formed, but the image was not produced by the means that nature showed him. All was condensed; the tones were lighter, the colours brighter, the values closer, the shades more diverse. The result was a whole of blond, tender harmony." Manet exhibited the painting at the 1882 Salon, and a month prior to opening, Paul Alexis, for Le Reveil, described "Standing at her counter, a beautiful girl, truly alive, truly modern". He wrongly predicted it would be a great success at the Salon.

ODD PERSPECTIVE Manet was accused of incompetence and lack of understanding of perspective. Critics were astonished by his obvious "mistake": that, since the bar was flat-on to the mirror, then the barmaid's customer was "missing". This caricaturist has "repaired the omission" and added the missing figure (right)

NEW ELECTRIC GLARE With the painting's silvery, blue-grey tones, and the blank white orbs reflected in the mirror, Manet has captured the cool brilliance of electric lighting, then starting to appear in the more exclusive venues.

ACROBAT In the top lefthand corner of the painting is the bizarre addition of a pair of legs with little green boots, and a trapeze. The presence of this acrobat serves to make the distracted barmaid seem all the more dispirited.

INCIDENTAL PORTRAITS Reflected in the mirror, we can see the busy, animated audience that holds no fascination for the world-weary barmaid. Two of Manet's friends are among the crowd: the woman in white is Méry Laurent (p. 60), and the woman in beige behind her is Jeanne Demarsy. Both 'cameos" were painted from portraits Manet had made previously.

MANET'S WORLD

In spite of the barmaid's elusive sadness, this is a joyous

MANET'S GRAVE Manet's tomb was inscribed with a tribute to him by his friend, Zacharie Astruc (p. 36).

Manet's death

MANET DIED OF A DISEASE called *locomotor ataxia*, an illness that attacks the central nervous system and causes paralysis. The disease was brought on by untreated syphilis, which Manet may have contracted as early as 1848 (p. 7). By the time of his death, it had reached its tertiary phase: he was 51. Manet's career began relatively late, but he

had a precocious talent and developed quickly. What he would have gone on to produce in his later years will, sadly, remain unknown. His last works reveal no deterioration of quality; quite the opposite, and we are cheated of Manet's final

telling mark of his generous spirit that towards the end of his life, even when illness forced him to leave his beloved Paris and urbane lifestyle behind to retreat into the country, his paintings continued to reveal unceasing optimism, curiosity, and a love of beauty: the mark of genius.

1esa beau any Mont be Paltin

A CARING COMPANION Méry Laurent was Manet's closest woman friend during his last years, and he wrote to her regularly. Renowned for her beauty, style, and generosity, she would send Manet flowers daily during his illness. According to George Moore (p. 37), she annually honoured the anniversary of Manet's death by placing lilacs on his grave.

AUTUMN 1882; 73 x 51 cm (28¾ x 20 in)

Manet's love of costume and decoration expressed itself over and over through the innumerable oil and pastel portraits he made of beautiful society women. He chose his friend Méry Laurent to pose for *Autumn* (right), and set off her rich colouring against a dazzling turquoise. She is wearing the fur pelisse over which, according to Proust, Manet was in raptures: "Ah, what a pelisse, my friend, a tawny brown with old-gold lining. I was stunned ... she has promised it to me. It will make a splendid backdrop for some things I have in mind." His love for women's fashions was well known, and his enthusiasm was shared with Mallarmé, who sometimes wrote under the pseudonym "Miss Satin".

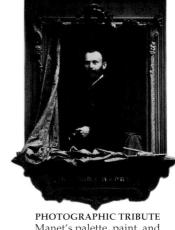

PHOTOGRAPHIC TRIBUTE Manet's palette, paint, and brushes have been placed at the front of this tribute to the artist who, in his usual nonchalent fashion, is smoking a cigarette.

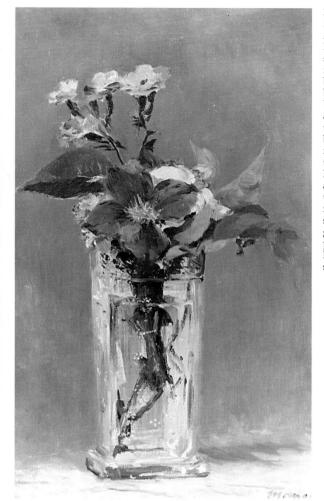

PINKS AND CLEMATIS IN A CRYSTAL VASE

1883; 56 x 35 cm (22 x 13³/₄ in) According to Tabarant, this was one of Manet's last works, part of a series of small flower paintings he produced in his few remaining months of life. This may be inaccurate, but what is certain is the brilliance of these small masterpieces. Uniformly stunning, they are full of the life and gaiety of Paris that, being confined to the country, he so missed. The squarebased crystal vase, decorated with tiny flowers, was one that Manet painted many times. Indeed, in most of his flower paintings he chose clear vases that revealed the stems and submerged leaves of the flowers. In this painting, the small handful of garden flowers appear to have been dropped straight into water, their stems still tied, giving an air of naivete to the work. Manet's paintings of fruit and flowers are among his least contrived works, and reveal a surprising, almost childlike, wonder.

La cure Laplaque d'endere Curin Henry Cecuro Annanuel You gales P. Puis ufha ge Timooif

Siverez pour Varmon 2 Mor 69

Mon clus Lops pour clus Lops Journiption you nous for adminatum de Manut pour athet son Olympic of i office and Homer. e who de plus tall homermage you man printing you and to get an articles to administration

i pense que von in prantine de primer part à primer part à primer de part primer de part primer de part primer de parts primer de part

Signatures of

mourners at

Manet's funeral

Fund-raising letter from Monet

MONET'S GESTURE

After Manet's death there was a move to secure a permanent home for *Olympia* (pp. 28–29) in the Louvre, organized by Monet. He was instrumental in raising, from Manet's friends and supporters, the amount needed to purchase *Olympia* from Manet's widow – motivated perhaps by gratitude to Manet for his help and support during Monet's difficult years. 12 AUGUEROBRE IX Paris of Mars 1907. Monsieur Le Directour

Enquête sur

MANET au Louvre

67 × 40

Monsieur

des œuvres du chef de l'école impre

l'occasion de l'entrée au Musée du Louvre

deux œuvres d'Edouard MANET et le Déjeuner sur l'Herbe, nous consa

et à cette occasion venons vous

Le Journal des Curieux

Nous yous en remercions à l'avance et vou

SEGIVICE

Monsieur Le Directeur. Manet an Vonve 'Je troine cela scanduleur. Mais ce sera aussi : par comparaison ause les cheffs d'ienare qui l'écrasserre f-

THE DEBATE CONTINUES

When Manet s *Olympia* (pp. 28–29) was finally accepted by the Louvre in 1893 (30 years after it was painted), the "Journal Amusant" sent out this questionnaire (left) to its readers, asking their opinion on the matter. There were many replies, of which this short example (above), declaring the very idea to be scandalous, was typical – reflecting Manet's ability, even in death, to provoke controversy.

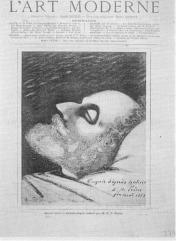

A PAINFUL DEATH For the last six months of his life, Manet endured almost constant pain. In March 1883 gangrene had developed in his left foot, and there was no option but to amputate. The operation was performed at his home on 19 April and he died, after great suffering, 11 days later.

FUNERAL BOOK

Antonin Proust (p. 6) was a speaker at Manet's funeral on 5 May 1883, and Claude Monet (p. 52) and Emile Zola (p. 28) were pall-bearers. The funeral book (left) contains signatures of those who attended, and is a record of a gathering of some of France's greatest names. This page alone was signed by the painters Pissarro, Boudin, Raffael, Sisley, Renoir, and the critic Paul Alexis.

Key biographical dates

1832 Edouard Manet born in Paris, 23 January.

1844 Enters the Collège Rollin. Meets Antonin Proust.

1848 Fails entrance exam to naval college. Sails to Rio de Janeiro on the training ship Le Havre et Guadeloupe.

1849 Stays in Rio de Janeiro for two months, then returns to Paris.

1850 Enters Thomas Couture's studio. Registers as copyist in the Louvre.

1852 Birth of Léon-Edouard Leenhoff, son of Suzanne.

1853 Travels to Dresden, Prague, Vienna, Munich, Normandy, Venice, Florence, and Rome.

1855 Visits Eugène Delacroix at his studio in the rue Notre-Damede-Lorette.

1856 Leaves Couture's studio; sets up studio in the rue Lavoisier with the painter, Albert, Comte de Balleroy. Visits Rijksmuseum in Amsterdam.

1857 Meets Henri Fantin-Latour at the Louvre. Travels to Italy.

1858 Meets Charles Baudelaire.

1859 The Absinthe Drinker is turned down by the Salon. Moves to new studio in the rue de la Victoire.

1860 Moves with Suzanne and Léon to an apartment in the Batignolles.

1861 Portrait of M. and Mme. Manet and The Spanish Singer shown at the Salon. The Spanish Singer receives honourable mention.

1862 Death of Auguste Manet, Edouard's father. Paints Music in the Tuileries. Meets Victorine Meurent.

1863 Shows Déjeuner sur l'Herbe at the Salon des Refusés. Manet marries Suzanne Leenhoff in Zalt-Bommel, Holland.

1864 Exhibits Episode from a Bullfight at the Salon.

1865 Olympia creates an uproar when shown at the Salon. Visits Spain.

1866 The Fifer and The Tragic Actor rejected by the Salon. Meets Cézanne and Monet. Frequents Café Guerbois.

1867 Holds major retrospective

exhibition alongside the Exposition Universelle, Paints first version of The Execution of Emperor Maximilian.

1868 Meets Berthe Morisot. Paints Portrait of Emile Zola.

1869 Eva Gonzalès becomes Manet's pupil and model. Exhibits The Balcony at the Salon, but The Execution of Emperor Maximilian (final version) is banned.

1870 Franco-Prussian war. Manet joins the National Guard.

1871 Elected to the artists' committee of the Paris Commune.

1873 Le Bon Bock shown at the Salon. Meets Stéphane Mallarmé.

1874 Offered the chance to exhibit at the first Impressionist exhibition, but refuses. Eugène Manet marries Berthe Morisot. Edouard spends the summer painting alongside Monet at Argenteuil.

1875 Shows The Seine at Argenteuil at the Salon. Travels to Venice.

1876 Paints Portrait of Stéphane Mallarmé.

1877 Nana rejected by the Salon.

1878 Paints Self-Portrait with Skull Cap.

• Glasgow

1880 Paints Portrait of Antonin Proust, which is then shown at the Salon.

1881 Antonin Proust becomes Minister of Fine Arts. Manet is awarded a second-class Legion of honour medal.

1882 Health worsens. A Bar at the Folies-Bergère is exhibited at the Salon.

1883 Left leg amputated 20 April. Dies 30 April.

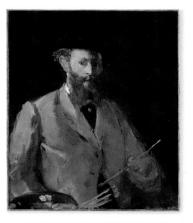

SELF-PORTRAIT WITH PALETTE c.1879; 83 x 67 cm (32³/₄ x 26¹/₄ in)

Manet collections around the world

The following shows the locations of museums and galleries around the world that own three or more paintings by Manet.

FUROPE Denmark

• Comenhager

Copenhagen Ny Carlsberg Glyptotek France

Paris Musée d'Orsay Lyon Musée des Beaux-Arts

Germany Berlin Neve Nationalgalerie Hamburg Kunsthalle Munich Neue Pinakothek

Norway Oslo Nasjonalgalleriet

Switzerland Winterthur Oskar Reinhart Collection Zürich Bührle Foundation UK

Glasgow Glasgow Museums and Art Galleries - The Burrell Collection Cardiff National Museum of Wales London Courtauld Institute Galleries: National Gallery

ASIA Japan

Tokyo Bridgestone Museum of Art

AUSTRALASIA Melbourne National Gallery of Victoria

62

Melbourne

Glossary

Academic art Art that conformed to the standards of the French Academy, the official body that promoted traditional art based on classical ideals

Broken colour Unmixed paint that is applied in mosaiclike patches, or dragged across a rough canvas or underpaint so that it is covers it irregularly.

Complementary colours Two colours are "complementary" if they combine to complete the spectrum. So the complementary of each primary colour - red, blue, and yellow - is the combination of the other two. Red and green; blue and orange; and yellow and violet are the basic pairs. In painting, placing complementary colours next to each other makes both appear brighter.

Ébauche The preparatory work on the canvas of what is intended to be a completed painting, giving the work a base in colour and tone.

En plein air (French: "In the open air.") Painting out of doors.

Flat colour An unmodelled area of colour - an evenly applied, unvaried expanse of red, for example.

History painting Paintings depicting historical, literary, legendary or Biblical scenes, intended to be morally uplifting. Considered by the Academics to be the highest form of painting

Hue The attribute of a colour that enables an observer to classify it as red, blue, etc., and excludes white, black, and grey.

Impasto

Illusionism The use of techniques such as perspective to deceive the eye into taking the painted image for that which is real.

Impasto Paint applied in thick, raised strokes.

Medium In paint, the vehicle (substance) that binds the pigment for instance, in oil paint the medium is an oil (poppy oil etc), in tempera the medium is egg.

Motif The dominant or recurring subject of a painting.

Naturalism Art that represents objects as they are observed.

Palette Both the flat surface on which an artist sets out and mixes paints, and the range of pigments used in painting.

Pastel A stick of powdered pigment mixed with just enough gum to bind the particles. (Also the name for a work of art using pastel.)

Peinture claire (French: "Painting light.") Painting with high-keyed tones to suggest bright, outdoor light.

Realism The French art movement, led by Gustave Courbet, that rejected the academic tradition in favour of unidealized paintings of ordinary people and objects.

Salon The official art exhibition in Paris, first established in 1667 by the French Academy and usually held annually.

Still life A painting of inanimate objects such as flowers or fruit.

Trompe l'oeil (French: "trick of the eye.") A painting containing elements within it which deceive the eye and the mind as to the material reality of a particular object.

Ukiyo-e (Japanese: "Pictures of the floating world.") A movement of 16th-and-17th-century Japanese painting and print-making that depicted contemporary scenes.

Vanitas Type of still life painting that flourished in the Netherlands in the early 17th century. Subjects were usually collections of objects symbolic of the inevitability of death and the vanity of earthly achievements and pleasures.

> Woodcut Relief print made from cutting into a design drawn on wood with a knife, gouge or chisel. The raised surface is inked and printed on paper, using pressure by hand or in a press.

Peinture claire

Lemon, Musée d'Orsay, Paris.

p. 34 bl: Soap Bubbles, Gulbenkian Foundation, Lisbon; br: Portrait of Eva Gonzalès, National Gallery, London.

p. 35 Peonies in a Vase, Musée d'Orsay, Paris.

p. 36 cl: Bullfight, Art Institute of Chicago; br: The Tragic Actor, National Gallery of Art, Washington.

p. 37 tl: Portrait of Emile Zola, Musée d'Orsay, Paris.

p. 38 bl: The Rag-Picker, Norton Simon Foundation, Pasadena; r: The Beggar (The Philosopher), Art Institute of Chicago.

p. 39 l: A Philosopher, Art Institute of Chicago; r: The Absinthe Drinker, Ny Carlsberg Gyptotek, Copenhagen.

pp. 40-41 The Fifer, Musée d'Orsay, Paris.

p. 42 tl: The Execution of Emperor Maximilian, Museum of Fine Arts, Boston; bl: The Execution of Emperor Maximilian, Städtlische Kunsthalle, Mannheim.

p. 43 The Execution of Emperor Maximilian, National Gallery, London.

p. 47 The Balcony, Musée d'Orsay, Paris.

p. 48 1: Portrait of M. and Mme. Manet, Musée d'Orsay; r: In the Conservatory, Nationalgalerie, Berlin; bl: At the

Café-Concert, Walters Art Gallery, Baltimore.

p. 49 tl: Portrait of M. Antonin Proust, Toledo Museum of Art, Ohio; br: Portrait of Stéphane Mallarmé, Musée d'Orsay, Paris.

p. 51 Le Bon Bock, Philadelphia Museum of Art.

p. 52 bl: Monet in his Studio Boat, Neue Pinakothek, Munich;

p. 53 tl: Self-Portrait with Skull Cap, Bridgestone Museum of Art, Tokyo.

pp. 54-55 The Seine at Argenteuil, Courtauld Institute Galleries, London.

p. 56 br: Nana, Hamburger Kunsthalle, Hamburg.

p. 57 tl: The Plum, National Gallery, Washington DC; bl: At the Café, Oskar Reinhart Collection, Winterthur, Switzerland; br: Corner of a Café-Concert, National Gallery, London.

pp. 58–59 bl: Roses in a Champagne Glass, Glasgow Museums and Art Galleries – The Burrell Collection: c: A Bar at the Folies-Bergère, Courtauld Institute Galleries, London.

p. 60 br: Autumn, Musée des Beaux-Arts, Nancy.

p. 61 tl: Pinks and Clematis in a Crystal Vase, Musée d'Orsay, Paris.

Manet works on show

The following is a list of the galleries and museums that exhibit the paintings by Manet that are reproduced in this book.

 $t = top \ b = bottom \ c = centre$ $l = left \ r = right$

p. 6 br: Portrait of Mme. Manet Mère, Isabella Stewart Gardner Museum, Boston.

p. 8 br: Venus of Urbino (after Titian), Kent Fine Art, New York; c: La Barque de Dante, after Delacroix, Musée des Beaux-Arts, Lyon

p. 12 1: The Old Musician, National Gallery, Washington DC.

p. 13 The Absinthe Drinker, Ny Carlsberg Glyptotek, Copenhagen.

p. 15 br: Boy with Cherries, Gulbenkian Foundation, Lisbon.

pp. 16-17 Music in the Tuileries, National Gallery, London.

p. 18 tr: The Spanish Singer, Metropolitan Museum of Art, New York; bl: Hand-painted Tambourine, Wildenstein Galleries, New York.

p. 19 tr: Lola de Valence, Musée d'Orsay, Paris; b: The Dead Toreador, National Gallery, Washington DC.

p. 20 tr: Woman with a Parrot, Metropolitan Museum of Art, New York; cl: Victorine Meurent, Museum of Fine Arts, Boston.

p. 21 The Street Singer, Museum of Fine Arts, Boston.

p. 23 c: Victorine Meurent in the Costume of an Espada, Metropolitan Museum of Art, New York.

p. 24 bc: Study for Le Déjeuner sur l'Herbe, Courtauld Institute Galleries, London

pp. 24-25 c: Déjeuner sur l'Herbe, Musée d'Orsay, Paris.

p. 26 br: The Surprised Nymph, Museo Nacional de Bellas Artes, Buenos Aires.

p. 27 tl: Reading, Musée d'Orsay, Paris; b: Mme. Manet at the Piano, Musée d'Orsay, Paris.

pp. 28-29 c: Olympia, Musée d'Orsay, Paris.

pp. 30-31 White Peonies and Secateur, Musée d'Orsay, Paris.

pp. 32-33 c: Still Life with Carp, Art Institute of Chicago; t: Bunch of Asparagus, Wallraf-Richartz Museum, Cologne; tr: The Asparagus, Musée D'Orsay, Paris; r: The Ham, Glasgow Museums and Art Galleries - The Burrell Collection; br: The

Index

А Absinthe (Degas), 12

The Absinthe Drinker, 12-13, 14, 18, 38, 39 Antonin Proust, 49 Argenteuil, 52, 54-55 The Artist's Studio (Courbet), 25 The Asparagus, 33 Astruc, Zacharie, 18, 19, 29, 36, 38, 60 At the Café, 57 At the Café-Concert, 48 Autumn, 60

В

The Balcony, 46-47 Balleroy, Albert de, 17 A Bar at the Folies-Bergère, 58-59 The Barque of Dante (Delacroix), 8–9 The Barricade, 45 Baudelaire, Charles, 12, 15, 16, 18, 58 The Beggar (Philosopher), 38 "Beggar-philosopher" series, 9, 13, 38–39 Bertall, 29, 53 Berthe Morisot with a Bunch of Violets, 46 Birth of Venus (Cabanel), 29 Blanc, Charles, 37 Le Bon Bock, 50-51 Bouquet of Violets, 32 Boy with Cherries, 15 The Bullfight, 19, 36 Bunch of Asparagus, 33

C Cabanel, Alexandre, 29 cafés, 14, 21, 58 Cariat, 51

Acknowledgments

PICTURE CREDITS

Every effort has been made to trace the copyright holders and we apologise in advance for any unintentional omissions. We would be pleased to insert the appropriate acknowledgement in any subsequent edition of this publication.

Key t: top b: bottom c: centre l: left r: right

Abbreviations

AIC: © The Art Institute of Chicago, All Rights Reserved; ATP: Musée des Arts et Traditions Populaires, Paris; BAA: Société des Arts et Traditions Populaires, et d'Archéologie, Paris; BM: Trustees of the British Museum, London; **B**N: Bibliothèque Nationale, Paris; **CG**: Courtauld Institute Galleries, London; **FAB**: Museum of Fine Arts, Boston; **MET**: Metropolitan Museum of Art, New York; **MM**: Musée Marmottan, Paris; **MO**: Musée d'Orsay, Paris; **NG**: Reproduced by courtesy of the Trustees, The National Gallery, London; courtesy of the Frustees, The Favorant Gallery, London, NGW: © National Gallery of Art, Washington, PC: Private Collection; PM: David A. Loggie, The Pierpont Morgan Library, New York, PVP: Photothèque des Musées de la Ville de Paris; RMN: Réunion des Musées Nationaux, Paris; VL: Visual Arts Library, London

p1: BN p2: tl: PM; tr: MO; cl: BN; c: Wildenstein Galleries, New York; cr: Musée de la Publicité, Paris, all rights reserved; bl: NG, br: Collections Royal Army Museum, Brussels, Db (a) 13981 p3: cl: PC; c: Gift of Richard C. Paine in memory of his father, Robert Treat Paine II, courtesy of FAB; bl: PM; br: PC/Giraudon, Paris P4: tl: PC; t: BN; tr: PM; cl: New Orleans Museum of Art/VL; cr: BN; tr: CM; cl: New Orleans Museum of Art/VL; cr: BN; tr: CM; cl: New Orleans Museum of Art/PL; cr: BN; tr: MO; bc: tr: PC; cl: Statens Konstmuseer, Stockholm; bl: BN; br: Isabella Stewart Gardner Museum Boston D7: tl: Revnolds Museum Gardner Museum, Boston p7: tl: Reynolds Museum

Champfleury, 30 Chardin, J.B., 30, 32, 34 Civil War, 44 Claude Monet, 52 Commune, 44-45, 51 Corner of a Café-Concert, 57 Corot, Camille, 47 Courbet, Gustave, 20, 22, 24-25.39 Couture, Thomas, 6, 9, 10-11, 13, 20, 34, 38

D

Daubigny, C.-F., 52 The Dead Toreador, 19, 44 Degas, Edgar, 12, 27, 33, 43, 46, 57 Déjeuner sur l'Herbe, 21, 22, 23, 24-25, 32 Delacroix, Eugène, 8–9, 15 Duret, Théodore, 14, 20, 44.52

E

Edouard and Madame Manet (Degas), 27 Edouard Manet (Fantin-Latour), 15 Emile Zola, 37 Ephrussi, Charles, 33 Eugènie, Empress, 18 Eva Gonzalès, 34–35 The Execution of Emperor Maximilian, 42-43, 45

FG

Fantin-Latour, Henri, 15, 53 The Fifer, 33, 39, 40-41 flâneurs, 14–15 Franco-Prussian War, 43-45 Gericault, Theodore, 8 Giorgione, 24 Goltzius, Hendrick, 34 Goncourt brothers, 57 Gonzales, Eva, 34 Gova, Francisco de, 36, 42, 46

El Greco, 36 Guillemet, Jules, 48

Η

Hals, Frans, 26, 50–51 The Ham, 33 Haussmann, Baron, 14, 38, 56 Head of a Boy, 11 Hokusai, Katsushika, 37 Homage to Delacroix (Fantin-Latour), 15

Impression: Sunrise (Monet), 52 Impressionism, 20, 41, 47, 50, 52-55 In the Conservatory, 48 Japanese art, 12, 36–37, 40, 56 Jeanniot, Georges, 33 Juarez, Benito, 42 Judgement of Paris (after Raphael), 24

ΚL

Kuniaki II, 37, 40 Laurent, Méry, 59, 60 Leenhoff, Ferdinand, 24 Leenhoff, Léon, 26-27, 34, 43, 47 Legros, Alphonse, 22 The Lemon, 33 Leroy, Louis, 52 Lola de Valence, 19 Louvre, 6, 8-9, 18, 46, 61

Μ

MacMahon, Marshall, 44, 50 Madame Manet at the Piano, 27 Mme. Manet Mère, 6 Madame Manet on a Blue

Couch, 27 Mallarmé, Stéphane, 37,

Winston Salem, North Carolina / Bridgeman Art Library, London; *tr*: photo: Mark Sexton **p7**: *cr*: PC; *b*: The Hulton Deutsch Collection **p8**: *tl*: ATP © photo: RMN; *cl*: Louvre, Paris/RMN; *bl*: Musée Carnavalet/ PVP © DACS 1993; *br*: Kent Fine Art, New York/Philippa Thomson, London **pp8**–91: :: Musée des Beaux-Arts, Lyon **p.10**: *1l*: BN; *tr*: Ackland Art Museum, The University of North Carolina at Chapel Hill, The William A. Whitaker Foundation Art Fund pp10-11: c: MO p.11: *tl*: BN; *tr*: © The Detroit Institute of Arts, gift of Mr. and Mrs. Edward E. Rothman; *br*: BAA **p12**: *tl*: BN; *bl*: Chester Dale Collection © 1992 NGW; *tr*, *cr*: ATP; *br*: MO p13 d: ATP, r: NY Carsberg Glybtotek, Copenhagen p14 d: ATP, r: NY Carsberg Glybtotek, Copenhagen p14 d: Ville de Paris, Service Technique de la Documentation Foncière; bl: PVP © DACS 1993; tr: BN; Documentation Foncière; bl: PVP @ DACS 1993; tr: BN; br: BN p15: ll: MO/VL; tr: Collection Union Française des Arts du Costume, Paris; d: Stickney Fund 1905;207, AIC; br: Gulbenkian Foundation, Lisbon pp16-17: NG p18: ll: BN; bl: Wildenstein Galleries, New York; tr. MET, gift of William Church Osborn, 1949 (49:58.2); br: Musée de la Publicité, Paris p19: ll: BAA; tr: MO; d: BN; cr: BAA; b: Widener Collection © 1992 NGW p20: cl: Gift of Richard C. Paine in Memory of his father, Robert Treat Paine II, courtesy of FAB; bl: PM; tr: KET, gift of Erwin Davis, 1889 (49:21.3), photo by Malcolm Varon; br: PM p21: l: Bequest of Sarah Choate Sears in memory of her husband, Joshua Montgomery Sears, courtesy of FAB; cr: Hulton Deutsch Collection Ltd p22: ll: BN; tr: Petit Palais/PVP w DACS 1993; cl: BAA; b: Collection Palais/PVP © DACS 1993; *cl*: BAA; *b*: © Collection Viollet **p23**: *tc*: © N.D. – Viollet; *tr*: PM; *cl*: Metropolitar Viollet **p23**: *t*:: @ N.D. – Viollet; *tr*: PM; *cl*: Metropolitan Museum of Art, bequest of Wrs. H.O. Havemeyer 1929, H.O. Havemeyer Collection, NGW **p24**: *cr*: Loure, Paris/@ Photo KMN; *cl*: BM; *b*:: CC **p24**-25: MO **p25**: *bl*: Musée Carnavalet/PVP/@ DACS 1993; *br*: MO **p26**: *it*, *r*, *cl*: BN; *bl*: Zalt-Bommel, Holland; *br*: Museo Nacional de Bellas Artes, Buenos Aries **p27**: *tl*: MO; *tr*: BN; *cl*: MO / VL; *bc*: MO; *br*: Kitakyushu Municipal Museum of Art, Japan **p28**: *tr*: Graudon, Paris **p28**-292; *c*: MO **p29**: *tl*: Uffizi, Florence/Scala; *tr*: BN; *cr*: MO; *cr*: (lower: BN; *tr*: BAA, **p30**-31: MO **p32**: *tr*: c: MO p29: If: Uffiz, Florence/Scala; If: bN; cf: MO; cf (lower): BN; br: BAA pp30-31: MO p32: Ir: PC/Giraudon; cf: Louvre, Paris/ @ Photo RMN; bf: MO p932-33: bc: Mr. and Mrs. Lewis Larned Coburn Memorial Collection, 1942.311, AIC p33: tf: Vallraf-Richartz Museum/Rheinisches Bildarchiv, Cologne; tr: MO; tc: BN; cr: Glasgow Museums and Art Galleries – Burrell Collection; br: MO p34: tf: BM; c: Gift of Mrs John Uffic: W. Simpson, NGW; bl: Gulbenkian Foundation, Lisbon;

48, 49, 60 Manet (Legros), 22 Manet, Auguste, 6, 26 Manet, Eugène, 24, 46 Manet, Eugenie-Desirée, 6 Manet, Gustave, 24 Manet, Suzanne, 30, 24, 26-27, 44-45, 61 The Manga (Hokusai), 37 Las Manolas au Balcon (Goya), 46 Mantz, Paul, 41, 49 Martinet, 19, 32 Maximilian, Emperor, 42-43 Las Meninas (Velàzquez), 36 Menippus (Velàzquez), 39 Meurent, Victorine, 20-21, 23, 24, 28–29, 33 Mexico, 42-43 Monet, Claude, 52-53, 54-55,61 Monet in his Studio Boat, 52 M. and Mme. Manet, 48 Moore, George, 37, 60 Morisot, Berthe, 32, 33, 41, 46-47,53 Music in the Tuileries, 14, 15, 16-17

N Nadar, Félix, 52 Nana, 56

Napoleon III, Emperor, 11, 22, 24, 29, 38, 42-43, 44 ΟP

The Old Musician, 12 Olympia, 8, 28-29, 32, 37, 41,61 Pablillos de Valladolid (Velàzquez), 36 Paris, 14-15, 38, 44-45, 56 Pastoral Concert (Titian), 24 Peonies in a Vase, 34-35 A Philosopher, 32, 39 Pierrot Ivre, 7 Pinks and Clematis in a

br: NG **p35**: MO **p36**: *tl*: © Museo del Prado, Madrid, all rights reserved; *tr*: Museo del Prado, Madrid/VL; *cl*: Mr. ngins reserved, in Museo del Frado Martin V e, et Mu and Mrs. Martin A. Ryerson Collection, 1937.1019, AIC; bl: © N.D. – Viollet; br: Gift of Edith Stuyvesant Gerry, NGW **p37**: tl: MO; bl: Bibliothèque Littéraire Jacques Doucet, Paris: tr: Babcock Collection, courtesy of the Doucet, Paris; ir: Babcock Collection, courtesy of the FAB; cr (np); BN; cr, br: Newark Public Library, New Jersey **p38**; bf: The Norton Simon Foundation; ir: Musée Carnavalet/PUP © DACS 1993; cr. A.A. Munger Collection, 1910;304, AIC **p39**; ir: ArAthur Jerome Eddy Memorial Collection, 1931;504, AIC; bf: BN; cr. NY Carlsberg Glyptotek, Copenhagen; br: @ Museo del Data Microiz all incidencementario (d. 11, MO edf). Carlsberg Glyptotek, Copenhagen; br: ® Museo del Prado, Madrid, all rights reserved pp40-41: MO p42: tł: Gift of Mr. and Mrs. Frank Gair Macomber, courtesy FAB; d: ® Museo del Prado, Madrid, all rights reserved; bł: Stadtische Kunsthalle, Munich; br: Collections Royal Army Museum, Brussels Db (a) 13981 p43: f: NG; bł: Collections Royal Army Museum, Brussels Db (b) 10228; br: BN p44: fi: BN; ci: AIC/VL; cr: PM; br: Musée Carnavalet/PVP @ DACS 1993 p45: ri, bł: Reproduced by courtesy of the Board of Directors of the Budapest Museum of Fine Arts; cr, br: BAA p46: fl: MET/MAS; bl, tr, cr, br: PC; p47: MO; tr: BAA; br: Jean-Loup Charmet p48: bl: MO; tr: BAA; cr: Staatliche Museen zu Berlin – Preussischer Kulturbeist: Nationalgaderie, photo: Jorg P. **P48**: bi: MO; tr: BAA; cr: Staatliche Museen zu Berlin − Preussischer Kulturbeitzt: Nationalgalerie, photo: Jörg P. Anders, Berlin; br: Walters Art Gallery/Visual Arts **p49** th: Toledo Museum of Art, Toledo, Ohio: purchased with funds from the Libbey Endowment; gift of Edward Drummond Libbey; tr: BN; cr: PW, br: MO **p50**: th: BAA; **b**: NG; br: BAA; tr: Rijksmuseum, Amsterdam; br: BN **p51**: Philadelphia Museum of Art: Mr. and Mrs. Carroll **5**: Tyson Collection; br: **BAA p52**: tr: PW © DACS **1993**. 5. Tyson Collection; br: BAA p52: tr: PVP © DACS 1993; cr: MM; bl: Neue Pinakothek, Munich; br: MM; p53: tl: Bridgestone Museum of Art, Ishibashi Foundation, Bragestone Museum of Art, Istubashi Foundation, Tokyo, tr: BAA; cr: BN; kc: MO; br: BAA p45; tl: PC pp54-55: CG (Courtauld Collection) p56: tl: BN; tr: New Orleans Museum of Art/VI; cl: Musée de la Publicité, Paris; c: BAA, Paris; bl: PN; br: Hamburg p5: tl: Sollection of Mr, and Mrs. Paul Mellon, © 1992 NGW; tr: MO; c: BN; cl: thanks to method. Mellon, © 1992 NGW; *tr*: MO; *c*: BN; *ct*: thanks to Dominique Ronot; bc: Sammlung Oskar Reinhart "Am Römerholz", Winterthur; *br*: NG **p58**: *c*, *bl*: Glasgow Museums and Art Galleries – Burrell Collection; *bc*: PC/VL, **p55**: **59**; CG (Courtauld Collection) **59**: *br*: BN **p60**: *tl*: PC; *br*: BN; *ct*: Bibliothèque Jacques Doucet, Paris; *br*: Musée des Beaux-arts, Nancy/@ Gilbert Mangin **p61** *tl*: MO; *tr*, *bl*, *bc*, *br*: BAA; *c*: PM Front cover. Clockwise from top left: BM; BAA; MO; PC; PC; MO; Wildenstein

Crystal Vase, 61 The Plum, 57 Poe, Edgar Allan, 37, 49 Polichinelle, 50 Prins, Ernest-Pierre, 48 Proust, Antonin, 6, 9, 10, 11, 16, 18, 21, 24, 49, 54, 60, 61

R

The Rag Picker, 38 Raimondi, Marcantonio, 10,24 Raphael, 24 The Ray Fish (Chardin), 32 Reading, 27 Rembrandt, 26 Renoir, Plerre, 53, 61 Rio de Janeiro, 6-7 Romans of the Decadence (Couture), 10 Roses in a Champagne Glass, 58 Rouvière, 36 Rubens, Peter Paul, 10, 26

S

Salon, 12, 18, 19, 20, 22-23, 28, 39, 40, 46, 49, 50, 51, 52, 58, 59 Salon des Refusés, 22-23, 24,28 The Seine at Argenteuil, 54-55 Self-Portrait with Skull Cap, 53 Signac, Paul, 35 Silvestre, Armand, 48 Soap Bubbles, 34, 44 Soap Bubbles (Chardin), 34 Spain, 18–19, 23, 36 The Spanish Ballet, 19 The Spanish Singer, 18, 32, 50 The Steamer, 7 Stéphane Mallarmé, 49 Still Life with Carp, 32 still lifes, 30, 32-33 The Street Singer, 21 A Studio in the Batignolles

(Fantin-Latour), 53 The Studio of Thomas Couture (Anon), 10 The Surprised Nymph, 26

tambourine, 18-19 The Third of May 1808 (Goya), 42 Titian, 8, 10, 24, 28, 29 The Toper (Hals), 50 The Tragic Actor, 36, 39, 40

UV

Utamaro, Kitagawa, 40 "Vanitas" paintings, 34, 35 Velàzquez, Diego, 18, 19, 36, 37, 38, 39, 51 Venus of Urbino (Titian), 8,29 Victorine Meurent, 20 Victorine Meurent in the Costume of an Espada, 23

W

Whistler, J.A.M., 23, 27 The White Girl (Whistler), 23, 27 White Peonies and Secateurs, 30-31 Wolff, Albert, 50, 53 Woman and Child (Morisot), 46 Woman with a Parrot, 20 Women Drinking Beer, 58 Women on a Café Terrace (Degas), 57 The Wrestler Onaruto Nadaemon of Awa Province (Kuniaki II), 37

ΥZ

Young Man in Majo Costume, 23 Zola, Emile, 12, 16, 29, 36, 37, 40, 56, 61

Galleries, New York; DK; MO; c: BN Back cover: PC; © Collection Viollet; MO; ATP/RMN; White Peonies and Secateur (detail), MO (also c, cl); PC; BN; Ny Carlsberg Glyptotek, Copenhagen; ATP Inside front flap: I: BN; b: MO.

Additional Photography Philippe Sebert: p2: tr; p3: cl; p4: tl; p5: br; p6: tr; p7: cr; pp10-11: c; p12: tr; cr, br; p13: cl; pp24-25; p25: br; p27: tl, bc; pp28-29: c; p29: cr; p290-31; p32: bl; p33: tr, br; p35; p37: bl; p46; p48: bl; p49: br; p53: bc; p54: tl; p57: tr; p60: tl; p61: tl; Alison Harris: p4: bc; p6: tl; p51: bl; Andy Crawford: front cover: cl; p14: tl; p15: cr; p20: tl; p40: tl; Guy Ryecart: p3: cr; p32: tl.

Dorling Kindersley would like to thank: Joanna Figg Latham for DTP assistance; Mme. Sevin at the Bibliothèque d'art et d'archaeologie; special thanks to M. Chapon, Conservateur en Chef at the Bibliothèque Litéraire Jacques Doucet; the staff at the Musée d'Orsay, Paris; Jacques Deville at the Bibliothèque Nationale, Paris; Hilary Bird for the index.

Author's acknowledgements: I would like to thank John Leighton and Emma Shackleton at the National Gallery, London, for their help and advice; Juliet Wilson-Bareau and Rosalind de Boland Roberts for providing much needed information. I would especially like to thank all those at Dorling Kindersley who contributed to this book, in particular the editor Phil Hunt, and designer Mark Johnson-Davies, Gwen Edmonds and Toni Kay, Helen Castle, and Jo Evans, with special thanks to Julia Harris-Voss for her energy and enthusiasm. Above all my thanks to Sean for all his patience and support.